LEGENDARY LOCALS

OF

SHREVEPORT
LOUISIANA

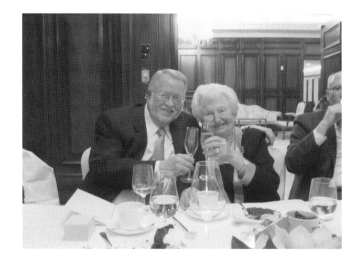

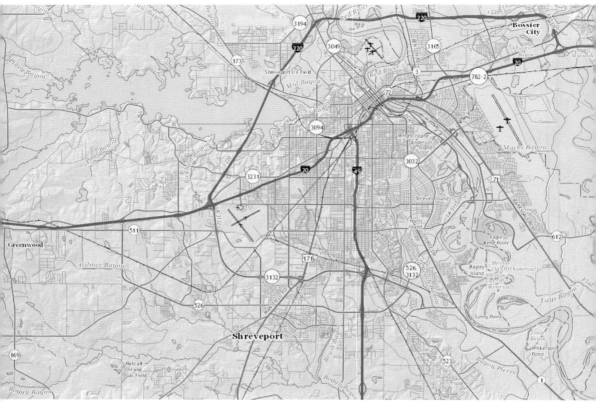

Map of Shreveport
This map shows the area of Shreveport, Bossier City, and Greenwood and includes the Red River and Cross Lake. (Courtesy of US Geological Survey.)

Page 1: Two Literati
Jim Montgomery and Virginia Shehee are two of Shreveport's best and brightest. Montgomery was a Pulitzer Prize–finalist journalist, and Shehee was one of the greatest philanthropists in the Ark-La-Tex region. (Courtesy of the *Shreveport Times*.)

LEGENDARY LOCALS

OF

SHREVEPORT

LOUISIANA

GARY D. JOINER AND JOHN ANDREW PRIME

LEGENDARY
LOCALS

Legendary Locals is an imprint of Arcadia Publishing
Charleston, South Carolina

Printed in the United States of America

Library of Congress Control Number: 2014938737

For all general information, please contact Arcadia Publishing:
Telephone 843-853-2070
Fax 843-853-0044
E-mail sales@arcadiapublishing.com
For customer service and orders:
Toll-Free 1-888-313-2665

Visit us on the Internet at www.arcadiapublishing.com

Dedication
To the men and women, past and present, who forged Shreveport into what it is today.

P4, **On the Front Cover:** Clockwise from top left:
Dr. Willis Butler, Caddo Parish coroner and pioneer in forensic pathology (courtesy of Archives and Special Collections, Louisiana State University–Shreveport; see page 96), Dr. John Bahcall, physicist and discoverer of the neutrino (courtesy of the *Shreveport Times*; see page 94), Billy Whisner, World War II and Korean War flying ace (courtesy of the *Shreveport Times*; see page 88), Mary Miles Minter, silent-film actress (courtesy of Archives and Special Collections, Louisiana State University–Shreveport; see page 26), Lt. Gen. Edmund Kirby Smith, commander of the Department of the Trans-Mississippi (courtesy of the Library of Congress; see page 84), James Burton, world-renowned guitarist (courtesy of Archives and Special Collections, Louisiana State University–Shreveport; see page 14), Sachihiko Ono Murata, Japanese pearl diver (courtesy of the *Shreveport Times*; see page 108), Rev. Harry Blake, senior pastor of Mount Canaan Baptist Church (courtesy of Archives and Special Collections, Louisiana State University–Shreveport; see page 95), Marcella Martin and Vivien Leigh in a still from *Gone with the Wind* (courtesy of the *Shreveport Times*; see page 24).

On the Back Cover: From left to right:
Col. John Riley Kane, recipient of the Congressional Medal of Honor (courtesy of the *Shreveport Times*; see page 83), Caesar Carpentier Antoine, Civil War veteran, politician, and businessman (courtesy of Archives and Special Collections, Louisiana State University–Shreveport; see page 58).

CONTENTS

ACKNOWLEDGMENTS

For their generous support during the writing of this book, we are indebted to Erin Vosgien and Arcadia Publishing. Their assistance and kind patience certainly exceeded the norm on this project.

This book would not have been possible without the kindness and help of many friends, some old and some new. We thank all of the people who took time from their busy schedules to answer questions, grant interviews, and provide us with images. Many of these photographs have not been published before, and some have not seen the light of day for many decades.

Archivists are historians' best friends. They are the keepers of primary-source documents and images that otherwise would be lost to society. It is with great gratitude that the authors wish to thank Dr. Laura McLemore, Dominica Carriere, and Fermand Garlington with the Noel Memorial Library Archives and Special Collections at Louisiana State University–Shreveport, and Chris Brown, archivist at Magale Library, Centenary College of Louisiana in Shreveport. Chris allowed us to use Centenary's resources and gave us permission to use his own personal collection. Newspaper archives are also of tremendous importance to a project like this. The authors wish to thank the *Shreveport Times* for permission to use its extensive collection of images.

The authors also wish to thank the Atkins family for allowing us to use an image of John Atkins. We also wish to thank our research assistant, Kate Hesson, for her exemplary service in helping gather and retrieve rare images from the various archives and collections. She made our lives much easier.

Choosing approximately 100 individuals to represent Shreveport from its early, violent past to its progressive, present-day period was daunting. The authors made hard choices among those who certainly belonged, and others who should be included, but were not due to lack of space. We realize that we could easily begin with a pool of over 1,000 people who made a difference to our city. We apologize to the hundreds of deserving people who are not included in this book.

The following sources are credited in abbreviated form in the courtesy lines: Archives and Special Collections, Louisiana State University–Shreveport (LSUS); Magale Library, Centenary College of Louisiana (Centenary); and the archives of the *Shreveport Times* (the *Times*).

INTRODUCTION

Shreveport, Louisiana, is a product of the Old West, a frontier town that, in the late 1830s, was the westernmost municipality in the United States. Shreveport was always intellectually, as well as physically, close to Texas. The attitudes of the early pioneers and the later immigrants who came west to build a new life reflected this frontier spirit much more than that seen in southern Louisiana. The original town, what is today the central business district, was built upon a diamond-shaped, one-square-mile plateau. The northern edge of the plateau rested against Cross Bayou. The combined water frontage of the bayou and the Red River afforded the town ample room for commercial growth. However, a major obstacle stood in its way.

Capt. Henry Miller Shreve, the man for whom Shreveport is named, received a contract from the US Army to remove a giant logjam known as the "Great Raft." Shreve was widely acclaimed as the most knowledgeable man on raft removal. When the French arrived and began exploration of the upper part of what is today the state of Louisiana, the raft extended south to Natchitoches, about 70 straight-line miles from the site of Shreveport. The upstream portion of the raft at times extended into Oklahoma. Since the meandering Red River had many curves, a straight-line mile might have as many as three river miles within it. At its largest, the raft clogged over 400 miles of river. By the time Shreve examined it, around 1830, the raft extended about 110 miles. Shreve used snagboats, catamaran steamboats for which he held patents, to do the work. He cleared the raft, entered into a business arrangement with local entrepreneurs, and formed the Shreve Town Company.

Henry Shreve surveyed the original townsite for Shreveport. It contained 64 blocks, and this is still the core of downtown Shreveport. The massacre of Texas loyalists at the Alamo was a recent event, and most people in the area either had relatives in Texas or owned land there. Thus, many downtown streets reflected the new community's political leanings. Texas Street, Crockett Street, Travis Street, Fannin Street, and Milam Street reflect the interest and connection to Texas, which was only 20 miles to the west. By 1841, Shreve had had falling-outs with both his business partners and the Army, and left the region to become harbormaster in St. Louis. He died there in 1851, never having lived in the town that bears his name.

During the Civil War, Shreveport was the Confederate capital of Louisiana from March 1863 until its surrender in early June 1865, two months after Robert E. Lee surrendered at Appomattox Court House, Virginia. The city had grown from about 4,000 people in 1860 to over 12,000 in 1865, not including troops stationed there. Refugees had poured into Shreveport from southern Louisiana and as far away as Missouri. After the war, many of these people remained in the city, among them an enterprising former Confederate captain from Missouri named Peter Youree. He would be instrumental in the creation of the modern city of Shreveport. By 1870, the city's population was estimated at 20,000.

A lingering problem in the South, one that no one understood fully until the end of the Spanish-American War, was the dreaded yellow fever. Epidemics were so frequent that the populace could count on one every other year. The general consensus was that the fever was caused by "bad air," or a miasma. In mid-August 1873, an epidemic broke out in Shreveport. Everyone who could leave town did, and the population dwindled to about 4,000 people before other towns sealed off the roads, railroads, and streams to protect their residents. A quarter of the remaining population died in the first two weeks, and another 50 percent contracted yellow fever in the next six weeks. Most of the doctors and nurses died in the first month.

In early September 1873, the US Army ordered its raft-clearing engineers out of the city, indicating that they should relocate farther south. Lt. Eugene Woodruff sent his men, including his brother George, to safety. He remained to help care for the residents of Shreveport. With most of the doctors dead

or ill, Woodruff and six Roman Catholic priests ministered to the victims. By the end of September, all of these good men had died from yellow fever. The epidemic occurred during Reconstruction, when anyone in a blue uniform was considered suspect at best and an agent of the devil at worst.

In many ways, the epidemic of 1873 was the city's turning point. Shreveport entered into a profound depression, saddled with the idea that it was an unhealthy place. New leaders with new ideas came to the fore, taking risks and investigating new opportunities. People like Peter Youree, Justin Gras, and many others made Shreveport into a modern city, proclaiming it the "Queen City of the Southwest."

Timber became the new economic miracle at the turn of the 20th century, quickly followed by oil and gas. The Ark-La-Tex region boomed with new opportunities, rapid increases in population, and the need for new controls on society. The common form of judicial procedure had been "rough justice." Rapid decisions, often by mobs, led to numerous lynchings. New judges and attorneys, aided by a coroner named Willis Butler, helped end this era and introduce modern jurisprudence.

Shreveport and the surrounding area blossomed with entertainment, the arts, and other, less glorious pursuits. Theaters, bawdy houses, Jazz Age musicians, and the entrepreneurs who ran them and hired them, all called Shreveport home. Since the Civil War, the city has been home to military bases and personnel. Some of these men and women attained notoriety for their exploits. The region and the nation as a whole have recognized them for their valor and their service.

This book brings to light many of the people and events in Shreveport's history. Many more could be examined, and the authors hope to do so in later volumes. Portions of this introduction are taken from *Lost Shreveport: Vanishing Scenes from the Red River Valley*, by Gary D. Joiner and Ernie Roberson (2010), which serves as a companion volume to this book.

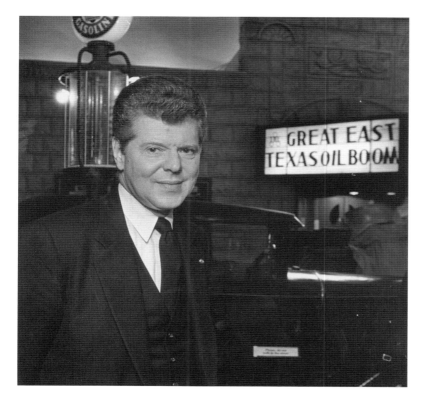

Van Cliburn
Van Cliburn is pictured at the East Texas Oil and Gas Museum around 1985. (Courtesy of the *Times*.)

CHAPTER ONE

Arts and Entertainment

The history of the arts and entertainment in Shreveport has, almost from the beginning, been filled with well-known luminaries. Shreveport has been home to jazz and blues musicians, rock 'n' roll greats, stage and screen actors and actresses, country-and-western singers, authors, fine artists, poets, composers, conductors, and comedians. Even as a rough frontier town in the 19th century, Shreveport found itself on a circuit of traveling entertainers. The town boasted four "opera houses" before the turn of the 20th century. Vaudeville acts, theatrical companies, singers, musicians, and circuses came to town. John Barrymore, Lillie Langtree, and many other top performers also came. The Jazz Age dawned, and the great performers of the day, Scott Joplin, Count Basie, Cab Callaway, Duke Ellington, and other greats, played at downtown hotels before the early crowds. Afterward, the performers played in "the St. Paul's Bottoms" to more lively audiences.

Country music beckoned, and with it, the *Louisiana Hayride* became the talk of the nation. The show was broadcast from Shreveport's Municipal Auditorium. Hank Williams, Roy Orbison, Slim Whitman, Red Sovine, and Elvis Presley first gained notoriety performing at the auditorium. The phrase "Elvis has left the building" was first uttered at this venue, because the screaming girls would not leave, hoping for another encore from the budding crooner. Authors have found Shreveport to be a great base for their labors. The late Eric Brock and Hal King are just two examples. Poets Judi Ann Mason and Ephraim David Tyler called Shreveport home. The Shreveport Symphony Orchestra was led for 33 years by John Shenaut, one of the great conductors of his time. Perhaps the best known of the current generation of graphic artists and animators is William Joyce. His Moonbot studio is at the forefront of animated movies. This chapter introduces some of the best of these artistic residents, past and present.

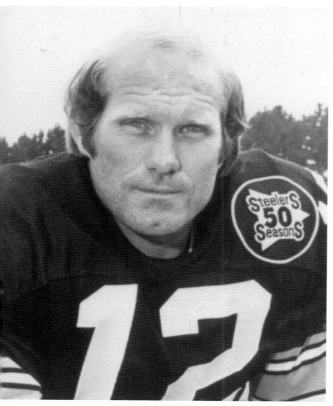

Terry Bradshaw

A football and sports-broadcasting legend, Terry Bradshaw (b. 1948) still calls his native Shreveport home, despite spending his preteen childhood in Iowa. The future hall of famer first amazed locals with his gridiron abilities at Woodlawn High School, from which he graduated in 1965, and then at Louisiana Tech, where he shared quarterback honors with future reality star Phil Robertson. As quarterback for the Pittsburgh Steelers from 1970 to 1983, Bradshaw led the team to four Super Bowl victories. Retiring from professional football in July 1984, he neatly segued into a career as a professional sportscaster, first with CBS and later with Fox. He has written or cowritten five books and recorded six albums, covering gospel and country-western music. Bradshaw hit the Top 20 and Hot 100 charts with a respectable cover of Hank Williams's "I'm So Lonesome I Could Cry." Nearing 70, Bradshaw remains one of the nation's most popular and endearing retired sports legends. (Both, courtesy of the *Times*.)

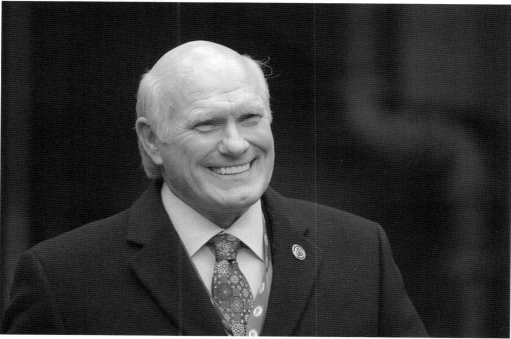

Eric John Brock

Brock was arguably the best-known historian to have lived in Shreveport. He was born in 1966 in Berkeley, California, and his family moved to Shreveport when Brock was a small child. He attended Centenary College in Shreveport, and soon after graduation turned his interests and talents to his great passions of regional history and historic preservation. Brock was a very popular author and columnist in Shreveport, writing over 500 articles in "The Presence of the Past" column for the *Shreveport Journal* and "A Look Back" in the *Forum Newsweekly*. Brock also authored or coauthored 10 books in 11 years, including *Shreveport, LA* (1998), *Red River Steamboats* with Gary D. Joiner (1999), *New Orleans* (1999), *New Orleans Cemeteries* (1999), *Centenary College of Louisiana* (2000), *Eric Brock's Shreveport* (2001), *Jewish Community of Shreveport* (2003), *Shreveport in Vintage Postcards* (2005), *Natchitoches Parish* (2007), *and Shreveport Chronicles: Profiles of Louisiana's Port City* (2009). His deep interest in historical preservation led him into the forefront of efforts to save historic buildings from demolition, whether by explosives or neglect. Local government agencies contacted Brock when the need arose; most residents in Shreveport would agree that it was often not enough. Through his columns and books, Eric Brock became the unofficial arbiter of Shreveport history and, in many cases, its conscience. His database of historic Oakland Cemetery was used by the City of Shreveport. He authored the text for over 100 historic signs placed in Shreveport, Caddo Parish, and Bossier Parish. While looking for a historic home, he found and purchased the Thornwell Plantation home in Shreveport's Highland neighborhood. Brock died of a heart attack at the young age of 45 in 2011. He and his wife, Shannon Glasheen Brock, were planning many new projects. Brock donated his substantial images, research collection, and memorabilia to Louisiana State University–Shreveport. (Courtesy of LSUS.)

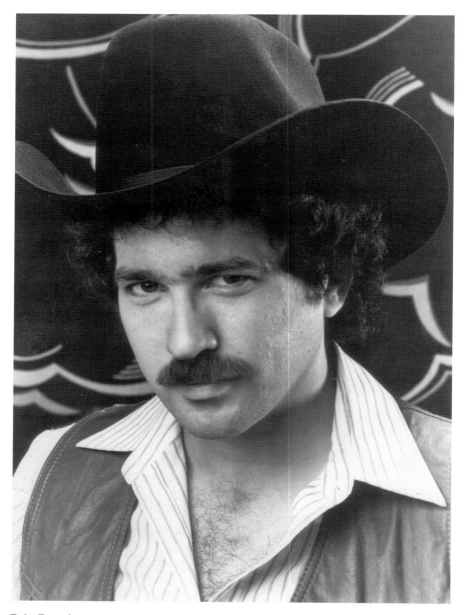

Leon Eric Brooks

Nicknamed "Kix" by his family for his energetic antics in his mother's womb, Leon Eric Brooks III (b. 1955) has carved a secure niche in the nation's music industry. A Shreveport-born songwriter, guitarist, and singer who commanded stages for 20 years with longtime partner Ronnie Dunn as the award-winning duo Brooks and Dunn, he has, since their breakup in 2010, also established a name as a movie producer and soundtrack composer, notably for the film *Ambush at Dark Canyon*. He and Dunn won more Country Music Association awards and Academy of Country Music awards than any act in the history of country music. With more than 30 million records sold and counting, Brooks remains one of the nation's most consistent recording and touring performers. He is a Louisiana Public Broadcasting Louisiana Legend and a member of the Louisiana Music Hall of Fame. (Courtesy of the *Times*.)

George Carlin

Comedian George Carlin (1937–2008), like many of the people who made Shreveport–Bossier City and Northwest Louisiana interesting, was not born here, but passed through and left transformed. He was stationed at Barksdale Air Force Base in the mid-1950s, barely out of his teens, assigned to the 376th Bomb Wing's 376th Armament and Electronics Maintenance Squadron. When he was off duty, he worked part-time at Shreveport radio station KJOE-AM, where another disk jockey, Wolfman Jack, also worked. Carlin was honorably discharged from the Air Force in 1957 and only made a few return visits to the area, where he filled concert halls with people who heard routines he only delivered here. For example, he poked fun at the time he was found asleep inside the wheel well of a B-47 bomber he was guarding on Christmas Eve, or the time he drank too much, professed his love for his squadron colonel's daughter on the radio, and returned to the base, only to discover he had been demoted to airman second class—yet again. According to obituaries and his official website, Carlin received three courts-martial and numerous Article 15 disciplinary punishments. (Courtesy of Chris Brown.)

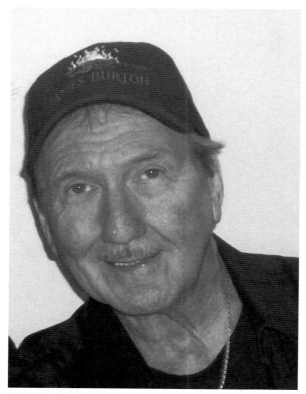

James Burton

A native of Dubberly in nearby Webster Parish, James Burton (b. 1939) grew up in Shreveport, where he listened to KWKH Radio and its legendary *Louisiana Hayride*. By age 14, he had begun to play guitar professionally. At the *Hayride*, Burton backed such stars as George Jones and Johnny Horton. Soon, Burton moved to Hollywood, where he started backing Ricky Nelson and worked with Glen Campbell, Dean Martin, Bobby Darin, the Everly Brothers, Merle Haggard, Buck Owens, and Frank Sinatra. In 1969, Burton accepted the call that made him famous: the invitation to form the band that would give Elvis Presley his comeback. Burton backed Presley until 1977, when the legendary performer died. In the 1970s, while with Presley, Burton also worked with Emmylou Harris and others. After Presley's death, Burton backed John Denver, leading that singer's band until his death in 1997. Burton also performed with Jerry Lee Lewis, Kenny Rogers, Elvis Costello, Bruce Springsteen, and Johnny Cash. He returned to Shreveport. By then a member of the Rock and Roll Hall of Fame, he started his James Burton International Guitar Festival in 2005, providing hundreds of scholarships and guitars to deserving children and young adults. (Both, courtesy of the *Times*.)

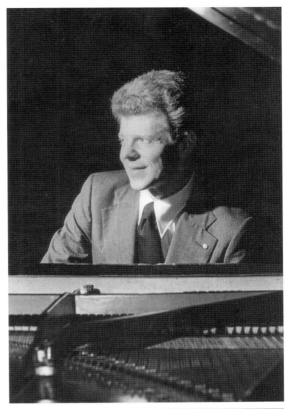

Harvey Lavan Cliburn

One of the rare performers known to the world by only one name, Shreveport native Van Cliburn (1934–2013) single-handedly helped thaw the Cold War when, in 1958, he won the grand prize at the initial Tchaikovsky International Piano Competition in Moscow. He moved Soviet leader Nikita Khrushchev to tears, received a ticker-tape parade at home, and became as popular in his day as Beyoncé is today. Born in Shreveport to noted local piano teacher Rildia Bee O'Bryan Cliburn and her husband, oil executive Harvey Lavan Cliburn, he moved with his family to the Texas oil boomtown of Kilgore when he was about seven years old. He sold millions of records in the 1960s and 1970s, helping to keep classical music alive as a retail commodity in an era overwhelmed by psychedelia, Southern blues-rock, and the British invasion. He founded the Van Cliburn International Piano Competition, a quadrennial competition hosted by the Van Cliburn Foundation. The event's prestige now rivals that of the Tchaikovsky competition. Cliburn retired from public life in the 1970s upon the death of his father, but he returned to the stage in 1987 to perform for Pres. Ronald Reagan and Soviet General Secretary Mikhail Gorbachev. He was then invited to open the 100th-anniversary season of Carnegie Hall. Van Cliburn played for royalty and heads of state from dozens of countries and for every US president from Dwight D. Eisenhower to Barack Obama. (Both, courtesy of LSUS.)

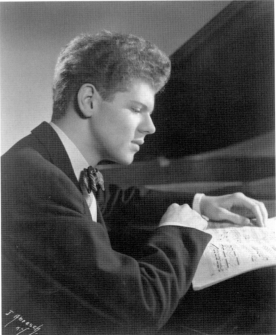

Clyde Connell

Connell (1901–1998) was a member of the Dixon family of Belcher, Louisiana. Her family owned five plantations and were large-scale farmers. She attended Brenau College in Georgia and, for a brief period, Vanderbilt University in Tennessee. Clyde married Thomas Dixon Connell, also of Belcher, in 1922. Thomas ran the Caddo Penal Farm from 1949 to 1959. The couple then moved to a cabin on Lake Bistineau. In those two venues, Clyde began a career in abstract sculpture, painting, and woodcuts. She attained fame in her 80s, exhibiting in major art venues in the United States and Europe. The Metropolitan Museum of Art in New York and many other institutions own her work. (Courtesy of John Andrew Prime.)

John William Corrington

Corrington, born in Memphis, Tennessee, in 1932, was a noted novelist, movie and television screenwriter, poet, and dramatist. Corrington received his bachelor's degree from Centenary College in Shreveport in 1956, his master's from Rice University in Houston in 1960, and his PhD from the University of Sussex, United Kingdom, in 1966. He taught English at Louisiana State University in Baton Rouge before earning a law degree from Tulane University Law School in 1975. He authored four books of poetry and volumes of short stories. He coauthored with his wife, Joyce Hooper Corrington, five screenplays, all made into movies. These were *Von Richtofen and Brown, The Omega Man, Boxcar Bertha, The Arena,* and *Battle of the Planet of the Apes.* The couple also authored a television drama, *The Killer Bees.* They wrote for several soap operas, including *Search for Tomorrow, Another World, Texas, General Hospital,* and *One Life to Live.* Perhaps Corrington's most important work that reflects the Louisiana, Mississippi, and Texas region was *And Wait for the Night,* which vividly described the Reconstruction era in this region. Corrington died in Malibu, California, in 1988. (Courtesy of Centenary College of Louisiana.)

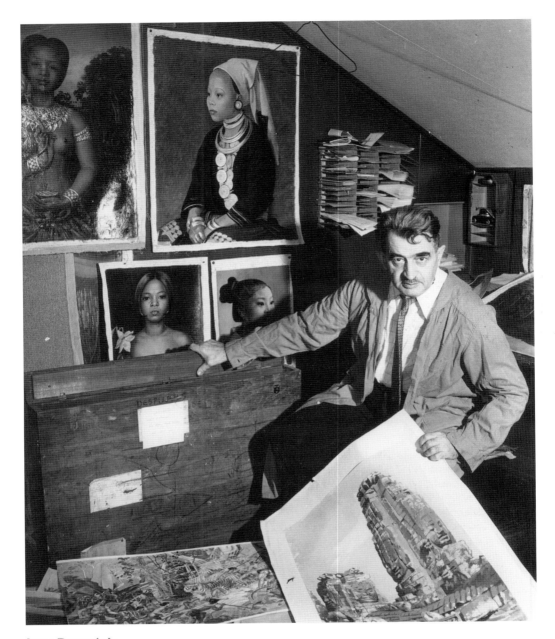

Jean Despujols

French painter Jean Despujols (1886–1965) adopted Shreveport as his home when he fled France to avoid Nazi occupation after an adult life largely spent in French Indochina. His wistful portraits, landscapes, and studies depict French Indochina before the destruction of World War II and the wars that followed. His greatest body of work is held at the Meadows Museum of Art at Centenary College in Shreveport, where he was sought after for his excellent portrait work. He was the recipient of numerous awards for his artistic skill and personal bravery in World War I, including the Prix de la Ville and Medaille d'or de Paris, the Premier Grand Prix de Rome de Peinture, the Prix de l'Indochine, the Croix de Guerre with six citations, the Medaille Militaire, and the Legion d'Honneur. (Courtesy of LSUS.)

Claude King

Country singer Claude King (1923–2013), a Keithville native who bought his first guitar at age 12, had a major country hit in 1962 with "Wolverton Mountain." It was cowritten with fellow Shreveporter Merle Kilgore, who later went on to manage yet another Shreveport country-music legend, Hank Williams Jr. King's other hits include "Big River, Big Man," "The Comancheros," "The Burning of Atlanta," "Sheepskin Valley," "Building a Bridge," "Hey Lucille!," "Sam Hill," "Tiger Woman," "Little Buddy," "Catch a Little Raindrop," and "All for the Love of a Girl." He also performed on the *Louisiana Hayride*. (Courtesy of the *Times*.)

William Joyce

Bill Joyce (b. 1957) has created a charming mystical universe deeply rooted in his views of the world and based on his life, upbringing, and family. He and associate Brandon Oldenburg won an Academy Award in 2012 for their animated short film *The Fantastic Flying Books of Mr. Morris Lessmore*. He has written and illustrated more than 50 children's books, from *George Shrinks* and *Dinosaur Bob and his Adventures with the Family Lazardo*, to *Rolie Polie Olie* and *The Leaf Men and the Brave Good Bugs*. He is working on a 13-book series of novels and picture books, "The Guardians of Childhood." *Newsweek* magazine called him one of the top 100 people to watch in the current millennium. (Courtesy of LSUS.)

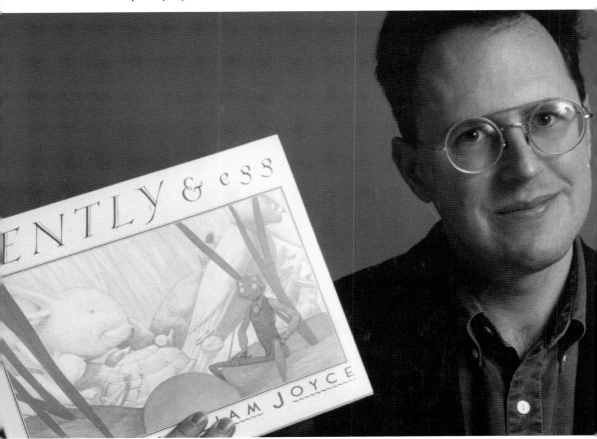

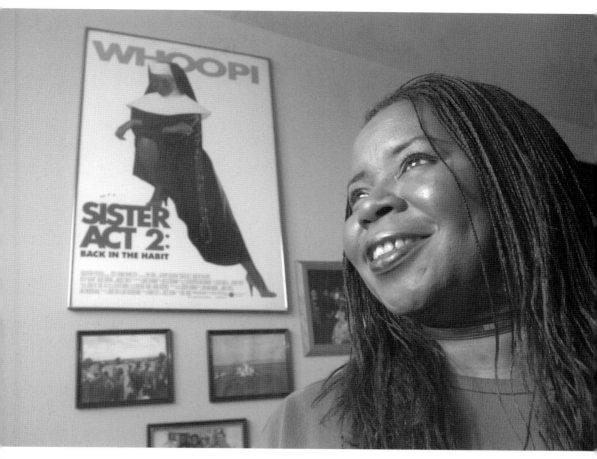

Judi Ann Mason

Shreveport native and sister of local civil rights activist Billy Joe "BJ" Mason, Judi Ann Mason (1956–2009) was working prodigiously as a playwright and television scriptwriter in Hollywood when she died suddenly at age 53. A protégé of Norman Lear and also a television producer, she wrote numerous award-winning plays, including *Living Fat* and *A Star Ain't Nothin' but a Hole in Heaven*. She also produced scripts for movies and television shows, including *Good Times*, *A Different World*, *I'll Fly Away*, *Sophie and the Moonhanger*, and *Sister Act 2: Back in the Habit*. Near the end of her life, she served as the inaugural national honorary chair of the first Southern Black Theatre Festival. (Courtesy of the *Times*.)

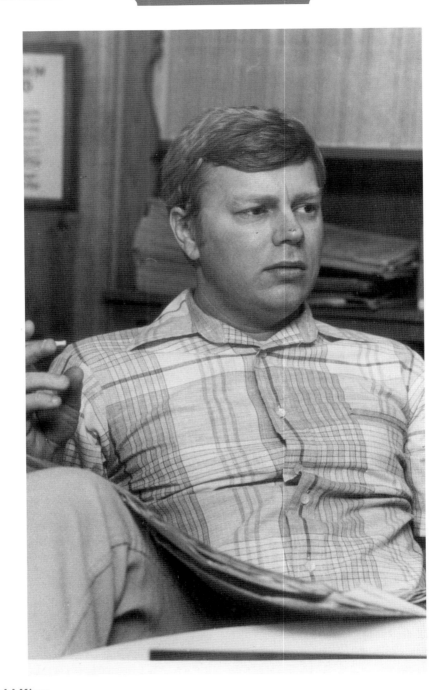

Harold King
Originally a police reporter with the *Shreveport Times*, Harold Raymond "Hal" King Jr. (1945–2010) entered the literary world with a bang in 1975 with the publication of his techno-thriller *Paradigm Red*, which was made into the 1977 television film *Red Alert*, starring William Devane. Other novels by King include *Four Days*, *The Taskmaster*, and the best-selling *Closing Ceremonies*, which led *Publisher's Weekly* to name King "the crown prince of suspense." (Courtesy of the *Times*.)

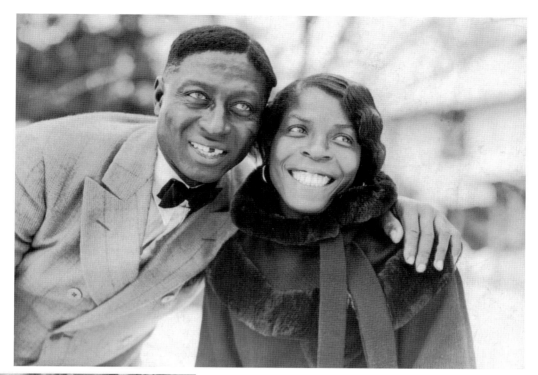

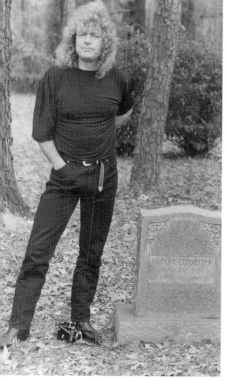

Huddie William "Lead Belly" Ledbetter

Born and buried at Mooringsport in north-central Caddo Parish, Huddie "Lead Belly" Ledbetter (1888–1949) is a traditional-music icon whose ability to translate black folk songs into anthems appreciated by all kinds of listeners has enriched the national culture. But, Ledbetter's nature fought against him almost all the way, with frequent encounters with the law, including prison terms for manslaughter and assault. Early on, he worked as an itinerant musician with "Blind" Lemon Jefferson, but, in 1918, he went to prison in Texas for murder. In 1930, Ledbetter again was imprisoned, this time at Angola in Louisiana after knifing a man in a fight in Mooringsport. At Angola, Ledbetter was heard by musicologists John and Alan Lomax, who worked to secure the singer's release under the state's "Good Time" law. Freed in 1934, Ledbetter toured and sang at Eastern colleges. Scores of his songs and commentary were recorded, and he was drawn into political causes, working with artists ranging from Woody Guthrie and Oscar Brand to Sonny Terry and Brownie McGhee. Just after his death, his song "Goodnight, Irene" become a hit for the Weavers. Other tunes for which he is justly famous include "The Midnight Special," "Fanning Street," "Pick a Bale of Cotton," and "Rock Island Line." Above, Ledbetter and his wife, Martha Promise Ledbetter, are pictured in 1935. At left, singer Robert Plant stands at Ledbetter's grave. (Above, courtesy of the Library of Congress; left, courtesy of the *Times*.)

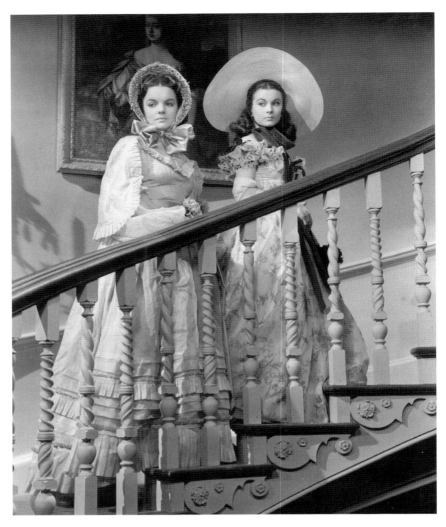

Marcella Martin

Elsie Marcella Clifford Martin Ferguson McGratty (left), better known by her stage name, Marcella Martin (1916–1986), was living in Shreveport and performing with the Shreveport Little Theatre when she was screen-tested for the role of Scarlett O'Hara for the pending production of *Gone with the Wind*. For some weeks, she was the leading candidate for the role, until Vivien Leigh (right) was tested and ultimately chosen. Martin nonetheless got a speaking role in the movie, as Cathleen Calvert. She also served as Leigh's coach in Southern dialect—ironic, since Martin was from Illinois and had to affect her own Southern accent. She was Leigh's roommate on location. Martin had roles in two other movies, playing Carol Barnet in *West of Tombstone* (1942) and Daphne Turner in *The Man Who Returned to Life* (1942). She played Ruth Collier in the 1969 episode "Boomerang" of the television series *The FBI*. In the lead-up to filming *Gone with the Wind*, Maxwell Arnow, David Selznick's scout searching for actresses to play Scarlett, interviewed scores of hopefuls. He reported to his boss about Marcella Martin in a memo dated November 16, 1938: "The results of the eighteen day trip through the South were quite meager with one exception. In Louisiana, at the Shreveport Little Theatre, ran across a girl by the name of Marcella Martin. This girl is quite good looking, has a nice figure, and is a grand actress. Without doubt she is the best of the hundreds of people that I interviewed during my trip." (Courtesy of the *Times*.)

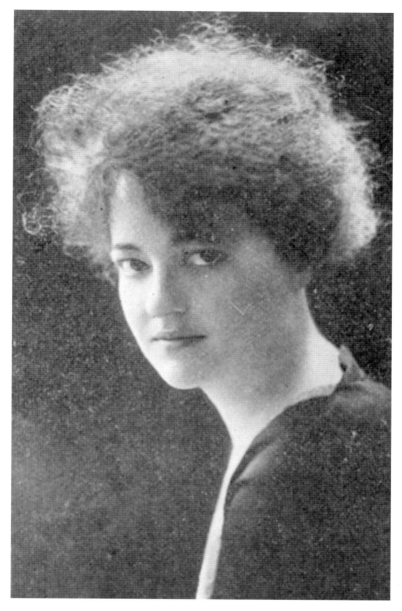

Margery Land May

Author Margery May (1898–1932) died young, at a time when she enjoyed a growing reputation in letters. The great-granddaughter of noted judge Thomas T. Land, she was a writer of short stories in the 1920s and a film screenwriter of some note. She slipped into a depression not long after the death of her husband, Shreveport attorney James Martin Foster, and committed suicide at their home, Currighmuir, which was located at the current site of the LSU Health Sciences Center at the Shreveport School of Allied Health Professions. Her film-writing credits include *Those Who Judge* (1924, from her novel *Such as Sit in Judgment*), *Destiny's Isle* (1922), *The Beauty Market* (1919, from her short story "The Bleeders"), and *By Right of Purchase* (1918, from her short story of the same name, written under the pen name Margery Land Mason). (Courtesy of the *Times*.)

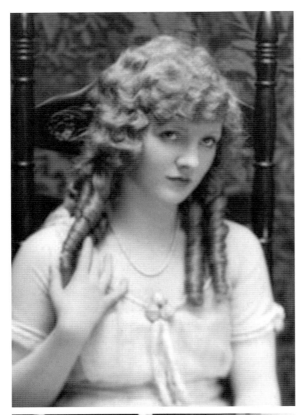

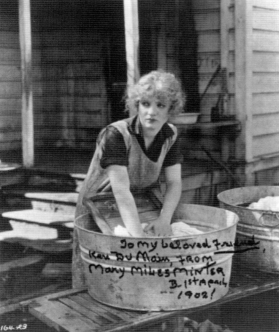

Mary Miles Minter

Noted actress and ingénue of the silent film era, Mary Miles Minter, (1902–1984), born Juliet Reilly in Shreveport, assumed the identity of a deceased cousin to avoid underage child labor laws and secured roles on stage and in film, becoming one of Broadway's more successful child actresses by 1911. Possessed of a delicate, almost angelic ethereal beauty, she appeared in 26 films between 1916 and 1918, only two of which have survived. Director William Desmond Taylor, who directed Minter in *Judy of Rogue's Harbor*, *Nurse Marjorie*, and *Jenny Be Good* and became her mentor, was found shot to death on February 2, 1922. His murder, which remains one of the great unsolved mysteries of Hollywood to this day, shocked the nation. Minter's involvement in the scandal—whispers accused her of an affair with Taylor and Minter's mother, actress Charlotte Shelby, was a suspect—ended the young actress's career, aided by the fact that she gained a lot of weight, lost her youthful beauty, and did not have a voice suitable for the new talkies. In 1981, she again entered the headlines after being brutally beaten, robbed, and left for dead after a home invasion. Minter rallied briefly but died three years later. (Both, courtesy of LSUS.)

James Ray Montgomery

A Minden native reared in Springhill, Jim Montgomery (1945–2013) was a veteran journalist, thespian, and civic activist in Shreveport. A graduate of Centenary College, he began his journalism career as a newscaster and reporter with KTBS-TV, and in 1969, joined the staff of the *Shreveport Times*. He served as amusements editor, member of the paper's enterprise team, editorial writer, editorial page editor, and managing editor. He then moved to the competing *Journal Page* as editor when the former afternoon newspaper became a daily independent op-ed page in the *Times*. After the *Journal Page* ceased publication, Montgomery served as a Shreveport city grant writer before spending the final eight years of his life as executive director of the Carolyn W. and Charles T. Beaird Family Foundation. Montgomery was a finalist three times for the Pulitzer Prize. The first time was in the 1970s as an editorial writer and as part of the enterprise team that investigated former public safety commissioner George D'Artois. The next time was in 1989, as part of the *Times* staff nominated for public service for education reporting. The last time was in 1994, as editor of the *Journal Page* for a 10-part editorial series, "Undoing Drugs," that called for serious study into alternatives to existing drug laws and enforcement. (Courtesy of the *Times*.)

William Darrell Overdyke

W. Darrell Overdyke (1907–1973) was born in Cherokee, Kansas, and died in Shreveport. He received a bachelor's degree from Centenary College in Shreveport, a master's from Louisiana State University, and a PhD from Duke University. Following his doctoral studies, he returned to Centenary College to teach history. Overdyke's interests centered on 18th- and 19th-century Louisiana planation homes and their architecture, as well as the 19th-century Native American or "Know Nothing" Party, in Louisiana and the South as a whole. Among his noted colleagues at Centenary were Walter M. Lowrey and Webb D. Pomeroy, a former student. These three men shaped the Department of History at the Methodist college. Overdyke was a charter member of the history fraternity Phi Alpha Theta and was a founder of the Southern Historical Association, the Louisiana Historical Association, the North Louisiana Historical Association, and the Louisiana Academy of Sciences. His books include *Louisiana Plantation Homes, Colonial and Antebellum*, *The American Party in Louisiana*, and *The Know-Nothing Party in the South*. His scholarship is remembered annually by the Overdyke Awards for best writing in north Louisiana history, given by the North Louisiana Historical Association. (Courtesy of Centenary College of Louisiana.)

John Shenaut

Galesburg, Illinois, native John Frederick Shenaut (1916–2011) left his adopted city, Shreveport, far richer culturally when he left it than when he arrived in the 1940s. He was enticed to the South to teach at Louisiana State Normal College, now Northwestern State University in Natchitoches, after establishing himself at Yankton College in South Dakota. He was conductor emeritus of the Shreveport Symphony Orchestra, which he helped found in 1948, conducting its first concert on November 9 of that year and leading the group for the next 33 years. Shenaut studied in the United States with Pierre Monteux and Rudolph Ganz and abroad with Rafael Kubelik in Lucerne, Nadia Boulanger and Eugene Bigot in Paris, Bernard Paumgartner at Salzburg's Mozarteum, Sergiu Celibidache in Prague, and Herbert Ahlendorf at the Academy of Music in Berlin. His earlier musical training was on the violin at Knox College Conservatory. Shenaut had an eye for spotting young talent. He was an early champion of Van Cliburn when the future master pianist was just a teen. Shenaut also started a symphony in Lafayette, and, when he was teaching in Natchitoches, began a symphony there as well. (Courtesy of LSUS.)

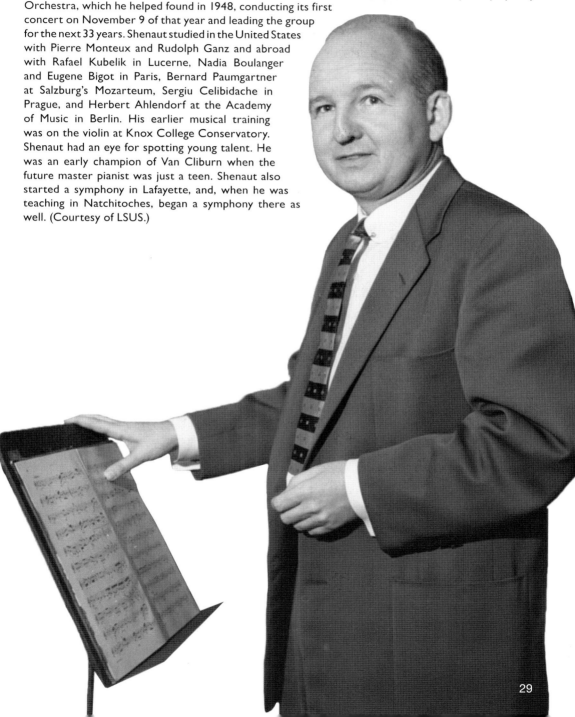

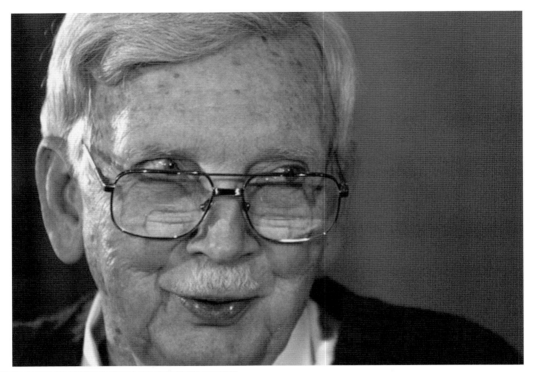

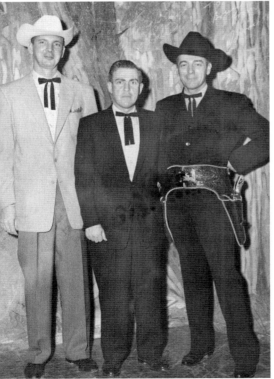

Raymond Frank Page

Tall, rumble-voiced broadcaster and journalist from Malvern, Arkansas, Raymond Frank Page (1925–2013) first gained fame as the announcer "Brother Gatemouth" on Little Rock radio and at Shreveport's KWKH, introducing blues to a generation of middle-class youth, including Robert Zimmerman, later known as Bob Dylan. In October 1954, Page was the first announcer to introduce the young Elvis Presley to a paying audience, at the *Louisiana Hayride*. Page, seen above and at left in the photograph on the left, was the dean of Louisiana broadcasters, working from the late 1930s until his retirement, in his 80s, in 2005. At first rejected by the military (too tall), he later was drafted into the Signal Corps and wound up in occupied Berlin in 1945, lodging in the house of former world heavyweight boxing champion Max Schmeling and sleeping in the boxer's bed, because it was one of the few that could accommodate his lanky frame. While at the *Hayride* from 1948 to 1960, and later at a revival of the show in the 1970s, Page introduced many stars, including Hank Williams Sr., Slim Whitman, Johnny Horton, Red Sovine, "Gentleman" Jim Reeves, and Nat Stuckey. (Above, courtesy of Centenary College of Louisiana; left, courtesy of LSUS.)

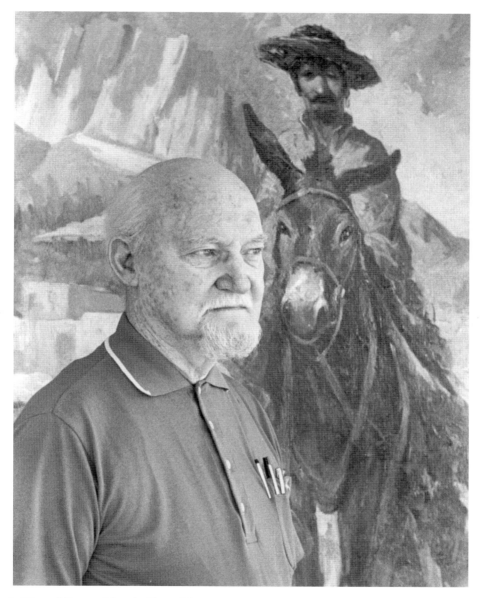

Louis Sicard Sr. and Louis Sicard Jr.

Louis Sicard was the name shared by father-and-son artists of the first order, who called Shreveport home and greatly enriched it with their talents. Sicard Sr. (1897–1990), born in New Orleans, was a well-known landscape and portrait artist and a member of the prestigious London Fellowship of the Royal Society of Arts and Letters. He also was a teacher and the recipient of numerous awards during a long artistic career. Sicard Jr. (1922–1991), also born in New Orleans, came to Shreveport in 1932 with his family and followed his father's career as an artist after service as a soldier in World War II. He saw much combat with the 116th Infantry of the 29th Division, participated in the Normandy invasion in the first-wave assault of Omaha Beach, and was awarded the Bronze Star and Purple Heart. Sicard Jr. (pictured) was well known for his sculpture, many examples of which remain in private collections. One of his large public works is in the gardens at the American Rose Center. (Courtesy of LSUS.)

Ephraim David Tyler
A natural poet and raconteur, Tyler (1884–1969) was referred to as the "Rustic Poet" and "Shreveport's Poet Laureate." He wrote extensively about everyday life, patriotism, and citizenship. For more than 60 years, Tyler wrote poetry for individuals, groups, and publications. He recited his work in schools and municipal auditoriums, on street corners, at church meetings, and at conventions. His works were recited as far away as Chicago, and in 1943–1944, he spent 14 months in California. He appeared on radio in California and at home. In September 1968, he was honored with a public reading of his poems by international playwright and actor Ossie Davis. (Courtesy of the *Times*.)

Keith Stegall
A singer and songwriter who lived much of his early life in Bossier City and Haughton, Robert Keith Stegall attended Centenary College, where he majored in theology. He moved to Nashville at the behest of Kris Kristofferson, where he has flourished as a songwriter and producer. He has written for Alan Jackson, George Jones, George Strait, Dr. Hook, and Clay Walker. His hits include "Pretty Lady," "I Hate Everything," "Sexy Eyes," "Whatever Turns You On," "California," and "We're in this Love Together." Stegall was born in 1955 in Wichita Falls, Texas. (Courtesy of Centenary College of Louisiana.)

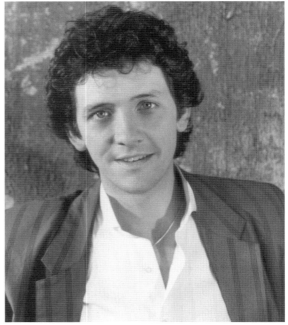

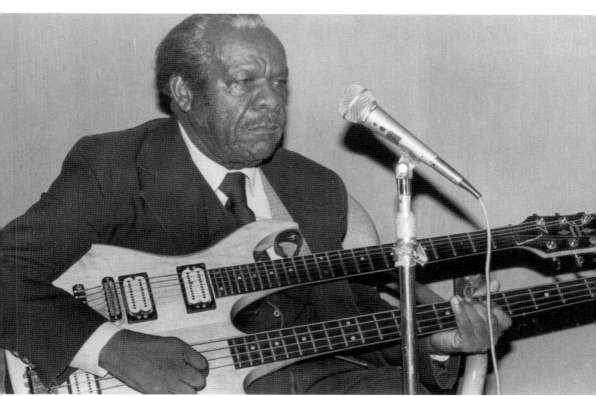

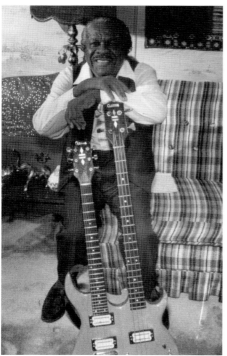

Jesse Thomas

Blues singer and guitarist Jesse "Babyface" Thomas (1911–1995) was best known for his 1929 song "Blue Goose Blues," written about a notorious section of Shreveport east of Fairfield Hill. The Logansport native was a fixture there before he left for Los Angeles, where he recorded for Victor and Specialty Records. His career spanned six decades, almost to the day he died. In 1994, well into his 80s, he performed at the Long Beach Blues Festival. He was a brother of Texas bluesman "Ramblin'" Thomas and the uncle of blues guitarist Lafayette Thomas. He lived much of his later years in Shreveport's Lakeside neighborhood, where he died. (Both, courtesy of LSUS.)

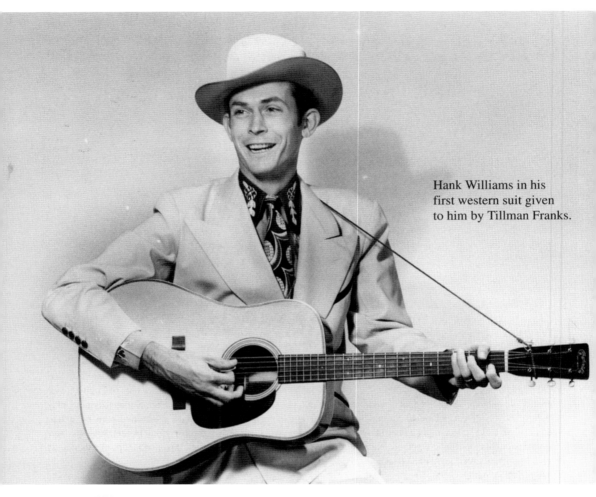

Hank Williams in his first western suit given to him by Tillman Franks.

Hank Williams
A music legend known for such tunes as "Your Cheatin' Heart" and "Hey, Good Lookin'," Hank Williams (1923–1953) lived in Bossier City and spent time in Northwest Louisiana when he was on the outs with the country-music establishment in Nashville. That was often, as his life became more troubled and tempestuous as he drove himself with his music and drink to an early death. He performed often on the *Louisiana Hayride* and was one of its original stars. He cemented his ties to the region in two notable ways. His son Hank Williams Jr. was born in Shreveport, and he married a local beauty, Billie Jean Jones, shortly before his untimely and legendary death at age 29. (Courtesy of the *Times*.)

CHAPTER TWO

Business

Shreveport has been, from the very beginning, an active trading center and a pro-business environment. The Red River and the Texas Trail combined to make Shreveport a vital commercial center. Once the giant logjam called the Great Raft was removed by Henry Miller Shreve, cattle flowed into Shreveport from Texas, and immigrants, finished goods, arms, and other items of trade traced their way back to Texas and beyond. Commercial activity began with Bennett and Cane's Bluff, today the eastern side of downtown Shreveport. From this frontier outpost, other entrepreneurs arrived. Shreveport quickly evolved into a wealthy cotton port, wholesaling and shipping the white gold downstream to other ports. Cottonseed oil mills created new jobs. After the Civil War, timber became prominent, and Shreveport provided the port facilities as the surrounding area harvested the timber, processed it in sawmills, and moved it by rail to other markets.

After the turn of the 20th century, oil and gas gave the region a needed boost after the old-growth forests were clear-cut. Oil and gas put Shreveport on the map. The largest known oil field in the world until the 1960s was found in northern Caddo Parish. The first over-the-water oil well was drilled in Caddo Lake. Mercantile ventures thrived in the mid-20th century. Rubenstein's, Selber Bros., M. Levi's, and other department stores lured more people into the area. Railroad barons like William Edenborn made Shreveport home. Rail service exploded as the great trunk-line railroads came to the region and developed hubs. Texas & Pacific, Kansas City Southern, Union Pacific, Southern Pacific, the Louisiana Railway & Navigation Company, and the Cotton Belt all had major facilities in Shreveport. This chapter highlights some of the entrepreneurs who have called Shreveport home and made it great.

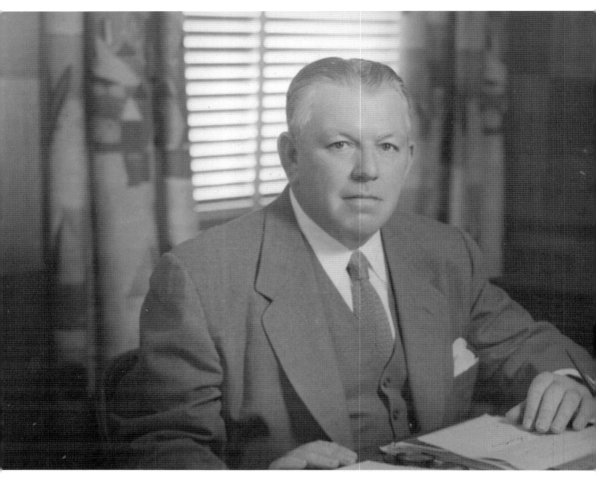

John Atkins

At least four successive generations of men from the Atkins family have borne the name John, and members of the family have remained active in the civic and business life of Shreveport and Northwest Louisiana. Perhaps the best known and most tragic figure of those bearing this name was John Baxter Atkins Jr. (1897–1954), financier and philanthropist. His death in a plane crash in January 1954 was just part of a litany of tragedies that haunted the city for decades. A veteran of the naval air service in World War I, he was one of six local and regional business leaders killed when their Grumman Mallard seaplane sustained iced wings and crashed on the shores of Caddo Lake. The men were returning from a duck-hunting expedition to south Louisiana. A native of Lake End in Red River Parish, John Atkins Jr. was an oil pioneer and chairman of the board of the Atlas Processing Company. He continued and advanced the business enterprises and social-education interests of his late father, on whose death he assumed control of the Shreveport–El Dorado Pipe Line Company. He was known for his support of Centenary College, which was drawn to Shreveport from Jackson, Louisiana, in the early 1900s after the Atkins family donated the land for what now is Centenary's notable campus. (Courtesy of the Atkins family.)

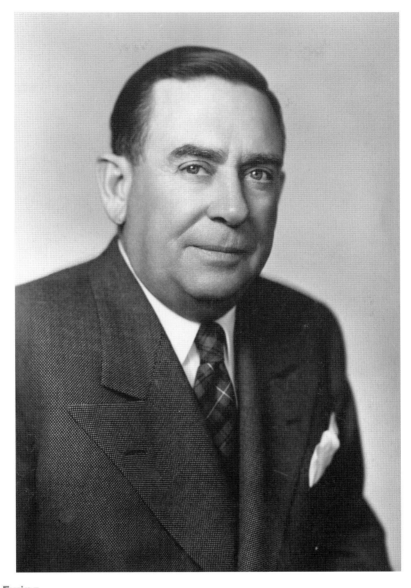

John D. Ewing

Capt. John Dunbrack Ewing was editor and publisher of the *Shreveport Times* from the death of his father, Col. Robert Ewing (1859–1931), to his own death by heart attack aboard his beloved Twin Beech plane *The Newsboy*. He served in World War I as a captain in Headquarters Company, 128th Infantry, 32nd Infantry Division. After the Armistice, John Ewing (1892–1952) was a founder of the American Legion and was the Legion commander in Louisiana. As editor and publisher of the *Times* and its sister paper in Monroe, the *News-Star*, he was a power in Louisiana journalism and politics from 1918 until his death. Like his father, who was one of the great and unique regional editors and publishers in the American South in the 20th century, John Ewing rigorously opposed Huey Long, the Ku Klux Klan, and Republicans. Largely responsible for bringing Barksdale Air Force Base into being, he also led the campaign to create Cross Lake, which remains Shreveport's main water supply 80 years later. Until his death, he was a major advocate of air power. (Courtesy of LSUS.)

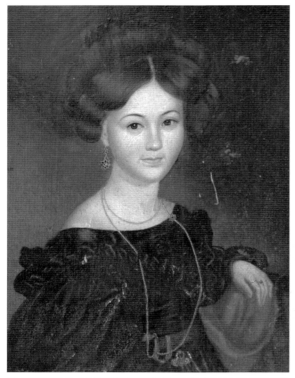

Mary Doal Ciley Bennett Cane

Mary Bennett Cane (1812–1902) was most probably the first pioneer woman of European descent to live in the Red River Valley north of Natchitoches. A native of New Hampshire, she moved west with her husband and business partner, Samuel Bennett. After his death, she married their business partner and her former beau, James Huntington Cane. Bennett and Cane's Bluff trading post became Shreveport. They were business partners of Henry Miller Shreve in the Shrevetown Company. Mary Bennett Cane and her husband ran a ferry service across the Red River, roughly where the Texas Street Bridge is today. The western terminus became the head of the Texas Trail. She is considered the mother of both Shreveport and Bossier City, the latter originally called Cane City. Mary Bennett Cane was the driving force behind civilizing frontier Shreveport. As a patroness of the arts, she encouraged "good" businesses to move to the young town. She helped organize theaters and concerts. She also worked behind the scenes to improve the lives of women and children. Her life, spanning between the War of 1812 to the year before the Wright brothers flew the first airplane, epitomizes 19th-century America. (Top, courtesy of LSUS; bottom, courtesy of Gary D. Joiner.)

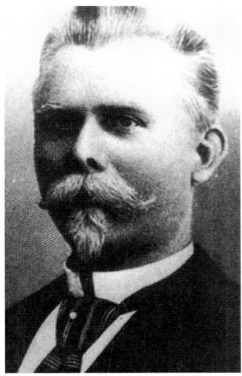

William Edenborn

Edenborn was born in Plettenberg, Westphalia, Prussia, in 1848 and immigrated to the United States in 1860, settling in Pittsburgh. He then moved to St. Louis and built the first wire mill in the west, in 1870. He made his fortune by creating a machine that made barbed wire safer. American Steel & Wire Company merged with J.P. Morgan's steel company to create US Steel in 1901. Edenborn moved to a plantation he named Emden in Winn Parish, Louisiana. His passion lay in railroads, and he created the Louisiana Railway & Navigation Company, which ran from Shreveport to New Orleans. He then built the short-line Louisiana & Arkansas Railway and became the chairman of the board of the Kansas City Southern Railroad. Edenborn and his wife also owned two steamships, the SS *William Edenborn* (below) and the SS *Sarah Edenborn*. He died in Shreveport of a stroke on May 13, 1926. Edenborn and his wife are buried in Forest Park Cemetery in Shreveport. The *Wall Street Journal* considered him one of the wealthiest men in America at the time of his death. (Both, courtesy of Shannon Glasheen Brock.)

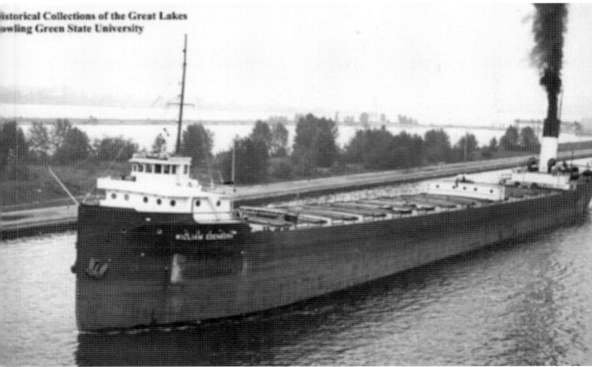

istorical Collections of the Great Lakes
owling Green State University

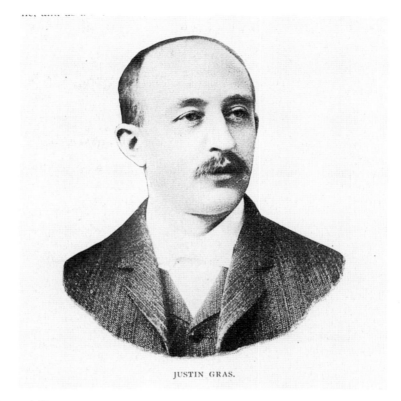

JUSTIN GRAS.

Justin Vincent Gras

Justin Gras, a native of Embrun, France, immigrated to America in 1891 to help his uncle Justin Riccou with his grocery business. After learning the trade, Gras, in 1895, embarked in his own business in Shreveport. He had three locations in downtown Shreveport by 1904. His main store was located at 727–729 Texas Street. He also had stores on Common Street and on Louisiana Avenue, near the corner of Milam Street. Gras became the largest individual landowner in the downtown area of Shreveport and soon became one of the largest landowners in Caddo Parish. He also owned property in New Orleans and in southwest Louisiana. Gras accumulated wealth very quickly through commercial rental property, his grocery business, and, especially, through liquor sales. He sold ceramic jugs of whiskey in several sizes, including multiple gallons; those containers have become collector items. Gras invested his wealth not only in real estate, but in stocks. He had a talent for picking new businesses that would become major players in the American economy. Among his holdings were major share positions in General Motors and Paramount Pictures. He knew that the nation's infrastructure would grow rapidly leading up to World War I. He invested heavily in transportation stocks, particularly railroads.

Gras (1868–1959) had a penchant for philanthropy, even before he attained great wealth. He gave back to his adopted city with zeal. His motto was "What is good for Shreveport is good for me." Gras was a major donor to Centenary College and to Roman Catholic endeavors in Shreveport, including the building of St. John Berchmans Cathedral, St. Vincent's Academy, and St. Mary's Convent. He was one of the founders of the Progressive Society, which, with Peter Youree, organized the Shreveport Chamber of Commerce. He also contributed to projects in his native France, including rebuilding his birthplace, Embrun, in the Pyrenees after an earthquake. Gras received an award from Pope Pius XII for his assistance in the rebuilding of the Cathedral of Embrun, originally constructed by Charlemagne. His greatest local legacy was funding the Community Foundation of Shreveport-Bossier. This came to fruition in 1961, two years after Gras's death, as part of his will. Gras died on September 19, 1959, at the age of 91. He is buried in St. Joseph's Cemetery in Shreveport. (Courtesy of Gary D. Joiner.)

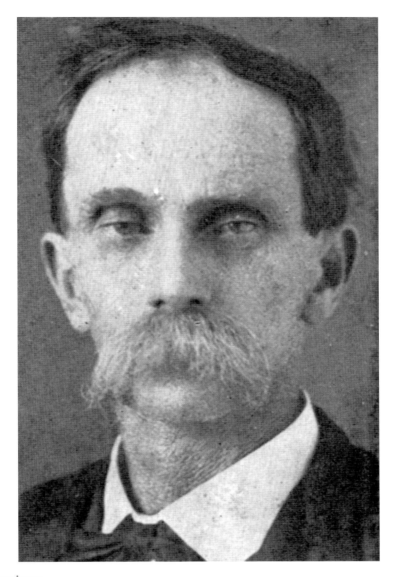

Victor Grosjean

A native of New Orleans, Grosjean (1844–1928) was among the first troops in Louisiana to enlist for Confederate service. As a private in Company A, Louisiana Guards, he was stationed in Pensacola, Florida, and then in Virginia. When his 12-month enlistment ended, he made his way back to Louisiana and reenlisted. He joined the 4th Louisiana Infantry Regiment and served at Vicksburg. Grosjean also participated in the Battle of Baton Rouge and at the siege of Port Hudson. He joined the Army of Tennessee and fought in the Georgia Campaign at New Hope Church, Kennesaw Mountain, and Atlanta, then the battles of Franklin and Nashville in Tennessee. He was captured and paroled. Finally, he served at Mobile and surrendered with the remnants of Richard Taylor's army. After the war, he married Alice Fory from Iowa and settled in Shreveport, where he became the publisher of the *Caucasian*, one of the leading newspapers in the state. He organized and led the General Leroy Stafford Camp of the United Confederate Veterans. Grosjean was also one of the organizers of the Louisiana State Fair in Shreveport. (Courtesy of Gary D. Joiner.)

Pete Harris

Restaurateur Pete Harris (1917–1992), more than any other figure in Shreveport's black community, worked to bridge the gap between the two sides of his adopted city's racial divide. The Campti native did this in the oldest and most proven way possible, by offering people the chance to break bread in a pleasing, safe, and comfortable setting. His signature eatery on Western Avenue, renamed Pete Harris Drive after his death in 1992, became a place where state leaders, from governors and attorneys general to district attorneys and community elites, met to dine and make deals that changed the profile of the city and the lives of its residents. Harris also delivered signature dishes to diners, notably some of the area's best soul food and battered stuffed shrimp, which old-timers still remember with savory fondness. (Courtesy of LSUS.)

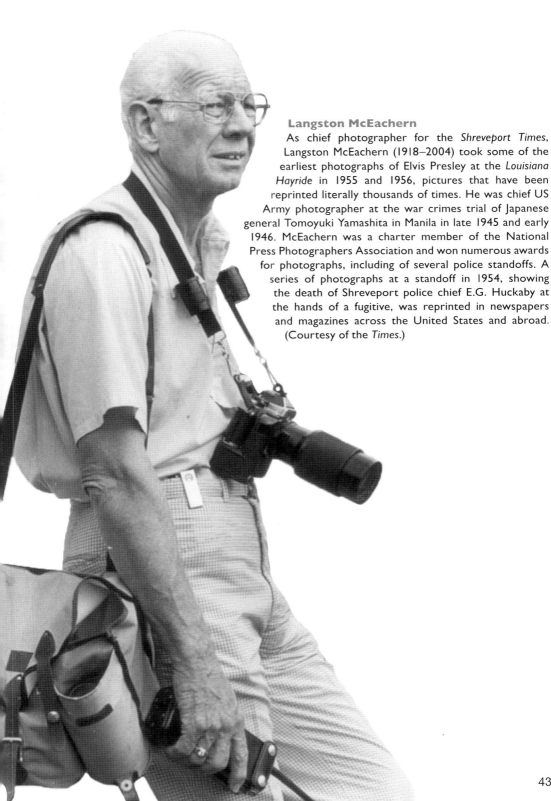

Langston McEachern

As chief photographer for the *Shreveport Times*, Langston McEachern (1918–2004) took some of the earliest photographs of Elvis Presley at the *Louisiana Hayride* in 1955 and 1956, pictures that have been reprinted literally thousands of times. He was chief US Army photographer at the war crimes trial of Japanese general Tomoyuki Yamashita in Manila in late 1945 and early 1946. McEachern was a charter member of the National Press Photographers Association and won numerous awards for photographs, including of several police standoffs. A series of photographs at a standoff in 1954, showing the death of Shreveport police chief E.G. Huckaby at the hands of a fugitive, was reprinted in newspapers and magazines across the United States and abroad. (Courtesy of the *Times*.)

O. Delton Harrison

Shreveport businessman and philanthropist O. Delton Harrison Jr. (b. 1931) joined the family business, the Harrison Company, and assumed the post of president in 1979. Over the last four decades, he has been a public and behind-the-scenes supporter of social and civic groups, ranging from the Shreveport Little Theatre to the Shreveport Opera. He has been nationally recognized for his work in support of the English Speaking Union, the New York Metropolitan Opera, the Metropolitan Museum in New York City, and the Dallas Grand Opera. (Courtesy of the *Times*.)

Albert Harris Leonard
A native of Columbus, Georgia, Albert Leonard moved with his family to Shreveport when his father, a steamboat captain, sought better job prospects. Albert (1839–1917) was a very unusual individual, even as a youngster. He recorded what he saw, and his early recollections provide us with the best images of early Shreveport. He saw gunfights on Texas streets, murders and escapes, and the small sagas of frontier life. When the Civil War began, Leonard volunteered for service in the 1st Louisiana Infantry Regiment. He sustained wounds in 1862 that resulted in his honorable discharge. He practiced law and was elected to the position of clerk for the district court in Caddo Parish. A state senator (1872–1876) and US attorney for Louisiana (1877–1897), Leonard was also a cofounder of the *Shreveport Times*, which began publishing in 1871. He was responsible for helping to bring the first natural gas well into the Ark-La-Tex region. (Courtesy of Gary D. Joiner.)

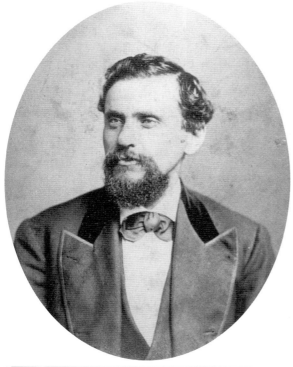

Simon Levy Jr.

A native of Alsace, France, Simon Levy (1839–1898) immigrated to Shreveport with his brother Samuel. When the Civil War began, he volunteered his service to the Confederacy, attaining the rank of captain. After the war, Levy married Harriette Bodenheimer, the daughter of Jacob Bodenheimer, who is believed to be the first Jewish settler in northern Louisiana. Simon Levy Jr. entered into business with passion. He operated a grocery store in Shreveport with his brother-in-law and served as the president of B'nai Zion Temple from 1879 to 1881. He also owned and operated The Banking House, the forerunner of Commercial National Bank. Levy was instrumental in bringing the Kansas City Southern Railroad to Shreveport and became a vice president of the line. Simon and Harriette were philanthropists of the highest order, helping to "civilize" the frontier. They had no children. (Courtesy of Gary D. Joiner.)

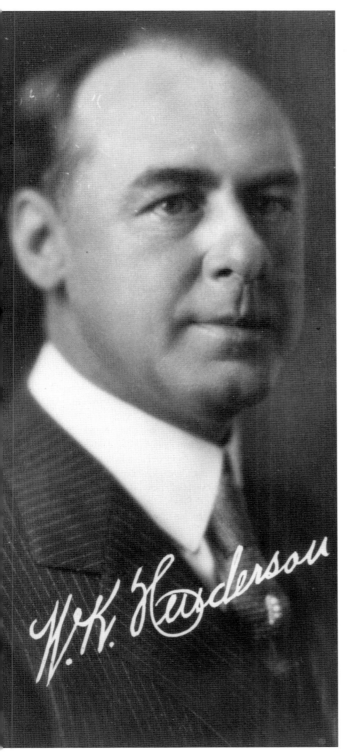

William Kennon Henderson Jr.
William Henderson (1880–1945) was a native of Morehouse Parish, Louisiana. America knew him as W.K. Henderson. He was a pioneer in the radio industry, buying radio station WGAQ in Shreveport in 1922 and renaming the call sign for himself, KWKH. The 50,000-watt station served his political and social agenda. Listeners tuned in from all across the central portion of the United States to hear his views. He began each show with, "Hello world, dog-gone you!" If the weather was good, listeners could hear the station from coast to coast, and occasionally in Europe. Henderson's fortune was made in the Henderson Iron Works and supply company, the largest in the industry south of St. Louis. He became one of the leading personalities in the nation for seven years. At first an ally of Gov. Huey P. Long, the two later fell out. Henderson sold the station in 1933. (Both, courtesy of LSUS.)

Edward Jacobs

Born Ephraim Jacobi in Freienwalde, Germany, Edward Jacobs (1822–1896) and his brothers arrived with only the clothes on their backs and became some of the wealthiest people in the region. Landing in New Orleans, Ephraim changed his name to Edward Jacobs, and his brother changed his name to Benjamin, to better assimilate. They soon came to the new town of Shreveport and established E&B Jacobs and Company, a successful mercantile on Texas Street. The Jacobses entered into many businesses, including banking and the lucrative cotton factor (wholesale), cottonseed oil refining, fur and tobacco, and real estate. Their bank, the E and B Jacobs Banking House, became the forerunner of First National Bank of Shreveport. The building still exists as the Spring Street Museum at 525 Spring Street. Edward Jacobs married Palestine Cole. His brother Ben married her sister, Amazon A. Cole. Both families produced many children, and the line still exists today. They supplied assistance during the great yellow fever epidemic of 1873, and Palestine helped fund the Genevieve Orphanage. Ed and Palestine Jacobs built one of the largest Victorian mansions in the region. (Both, courtesy of LSUS.)

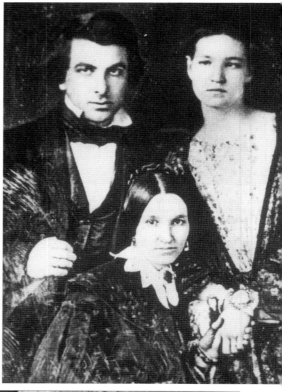

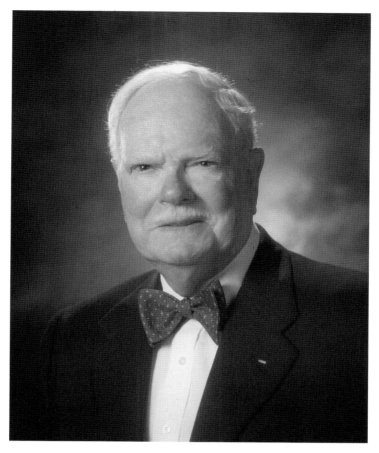

Norman Kinsey

Businessman, philanthropist, and civic leader Norman V. Kinsey (1921–2011) was part of the invasion fleet that landed in Morocco and fought across North Africa in World War II, ultimately finishing the war in Italy. His military decorations included an amphibious-assault arrowhead, nine battle stars, two Presidential Unit Citations, and the Bronze Star for exceptional service in support of combat operations. He returned to Shreveport a major and reentered LSU Law School in January 1946, earning two degrees in 1947, a bachelor's in business administration and a law degree. He then returned to Shreveport to join his father in business during the pioneering days of the postwar oil and gas boom. They developed the Carthage Field in East Texas and helped found Transco Energy Company, Pacific Northwest Pipeline, Texas Illinois Natural Gas Pipeline, and Piedmont Natural Gas Company. Kinsey's business ventures ranged from exploration, production, and transportation of energy to real estate development, timber, and venture capital investment.

Kinsey cofounded the Montessori School for Shreveport and the Ridgewood Montessori School. He established the LSUS American Studies Program and annually sponsored fellowships for Caddo Parish secondary school teachers to attend the Colonial Williamsburg Summer Teachers Institute. A participant in the Tarshar Society and the Raleigh Tavern Society of Colonial Williamsburg, Virginia, he also was an active member of the US State Department Fine Arts Committee. Byrd High inducted him into its hall of fame in 1999, and LSU–Baton Rouge inducted him into the E.J. Ourso College of Business Hall of Distinction in 2000 and the LSU Distinguished Alumni Association in 2008. LSU-Shreveport named him Pilot of the Year in 2001. In May 2011, Louisiana Public Broadcasting honored him as a Louisiana Legend. (Courtesy of the *Times*.)

Annie McCune

McCune (c. 1850–1920) was the most famous and powerful of the madams in Shreveport. She arrived in Shreveport in 1873 and quickly rose from being a prostitute to a madam, employing many girls and workers in several bordellos and smaller shotgun houses. Shortly after arriving, she worked in a brothel on the riverfront, located where the Sam's Town Casino is today. Her first known brothel was near the corner of Common and Milam Streets. This was a prime location on the Texas Road. It was common practice for railroad men, particularly engineers who frequented the bordellos, to bring their red-lensed railroad lanterns with them so their crews could find them in case of emergency. The term "red-light district" quickly identified clusters of brothels. Prostitution was widespread in Shreveport, and the city government and churches, aware that it could not be eliminated, decided to contain it in 1903. They passed an ordinance setting up a legal red-light district that stretched roughly from north of today's First Methodist Church to the Texas & Pacific Railroad tracks, west to Elm Street, and then to a convoluted boundary along Beauregard Street to the intersection of Common and Caddo Streets. McCune was largely responsible for determining the district's limits. The boundary encompassed all of her holdings. It became the second-largest such district, per capita, in the nation after Storyville in New Orleans.

Prices of everything were higher in the district, from rents to liquor. A 10¢ bottle of beer in Shreveport might cost $1 inside the district. It operated legally from 1903 to 1917. McCune had the first electric advertising sign at her 99 Club. It was large enough to be seen for several blocks in all directions. McCune was a suffragette, advocating for women's rights, and a leader in advocating for public health. Her clients included most of the top officials in the region; thus, although occasionally arrested, she was always able to avoid major penalties. She was believed to have been about 69 years old at her death in 1920. She never allowed herself to be photographed or drawn. She is buried in Oakland Cemetery, her grave within eyesight of her home and the 99 Club. (Courtesy of LSUS; original art by Jasmine Morelock, 1980.)

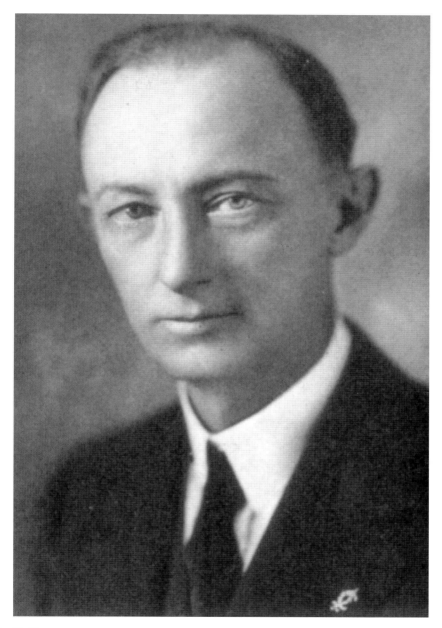

Randle T. Moore

A noted civic and business leader whose palatial Kings Highway residence is now Shreveport's premier senior center, Randle Thomas Moore (1874–1957) was primarily known as a foe and lifelong enemy of local attorney and later Louisiana governor Huey P. Long. In the 1920s, Moore encountered Long on Texas Street downtown and caned his foe, chasing him down the street and beating him as they ran. A native of Mooringsport, Moore started work at age 15 in a general store in Texarkana, Texas, also picking cotton as a youth. At age 27, he ventured to Sabine Parish, where he partnered with a lumber company, beginning a rise in business and social activity that led to success in railroad, construction, and banking ventures. (Courtesy of the *Times*.)

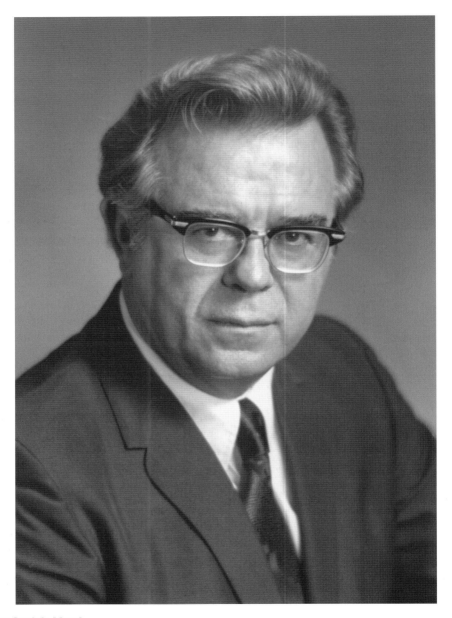

James Smith Noel

James "Sonny" Noel (1912–1998), a native of Caddo Parish, was an avid collector of rare books. He and his wife, Ruth Herring Noel, shared an interest in obtaining things of beauty, particularly pre-20th-century books for him, and art for her. Sonny Noel's fortune came through his family and was based on real estate and oil. The family owned much of the Caddo Pine Island Oil Field in northern Caddo Parish. A tough negotiator, he parlayed his skills into building his tremendous collection of books, which consisted of over 200,000 volumes. At one time, he owned the Texas & Pacific Railroad terminal to store them and employed two full-time librarians to catalog and acquire additional copies. He donated his collection to Louisiana State University–Shreveport in 1994. The university's library bears his name, as does the extensive archives that bears his name and houses the collection. (Courtesy of LSUS.)

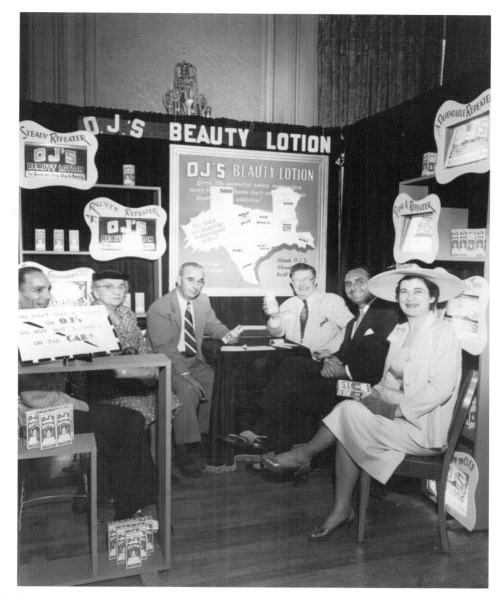

Ortha James Parham

O.J. Parham (1882–1955), a Texas pharmacist and businessman, developed OJ's Beauty Lotion, an astringent that, for many years, was a staple beauty aid for many women, particularly in the South. He developed the lotion for his wife, Minnie Craig Parham, who had skin problems, and started selling it in 1903. The Parhams moved to Shreveport in 1910, and O.J. became manager of the Carter (later Carter-Mayfield) Drug Company at 326 Texas Avenue, where the lotion was made in the back of the store. Later, production was at a house on Spring Street, with a plant finally opening in the 3800 block of Florence Street. After Parham died in 1955, his widow and daughter continued to make and sell the now-famous beauty product, which survived Minnie Parham's death in 1964. The family business closed in August 1984, and the rights to the product were purchased by Goody's, which later stopped producing it. (Courtesy of LSUS.)

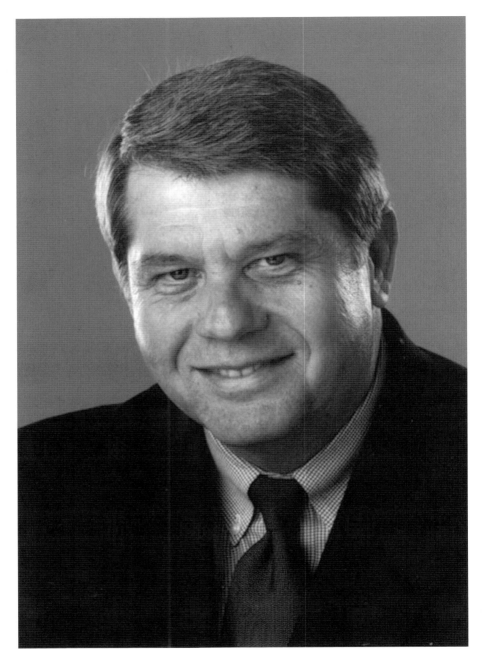

Stanley Tiner
The executive editor and vice president of the *Sun Herald* newspaper in Biloxi-Gulfport, Mississippi, Tiner (b. 1942) is a former political reporter, editorial-page writer, and editor with the *Shreveport Times* and editor of the now-defunct *Shreveport Journal*. Earlier, the Springhill native briefly was executive editor of the *Daily Oklahoman* in Oklahoma City and editor of the *Press-Register* in Mobile, Alabama. The *Sun Herald* won the 2006 Pulitzer Prize for public service for its coverage of Hurricane Katrina. (Courtesy of the *Times*.)

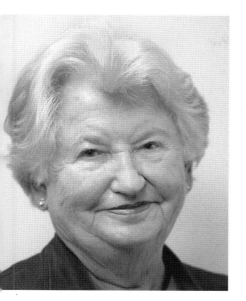

Virginia Shehee

Prominent Northwest Louisiana businesswoman, political activist, and philanthropist Virginia Ruth Kilpatrick Shehee (1923–2015) was involved with many causes in Shreveport and Northwest Louisiana, from Oakland Cemetery and the Louisiana State Fair to the Strand Theater, which she helped save, and the Shreveport Symphony Orchestra and Centenary College, which she supported in ways monetarily and beyond. She entered active public life in 1971 after her mother, Nellie Peters Kilpatrick, died in an airplane crash. Heading the family concerns Kilpatrick Life Insurance Company and Rose-Neath Funeral Homes, Shehee led a powerful and diverse business base that allowed her to enter into politics and philanthropy. She served from 1976 to 1980 as the state senator from District 38 in Caddo and DeSoto Parishes, winning her seat in the 1975 general election by 23 votes over incumbent C. Kay Carter. She helped build the former Fountain Towers, a signature structure on Fairfield Avenue, and, in Bossier City, she created Rose-Neath Cemetery. She also was chairwoman-emeritus of the Biomedical Research Foundation of Northwest Louisiana, which in 1996 was renamed in her honor. (Both, courtesy of the *Times*.)

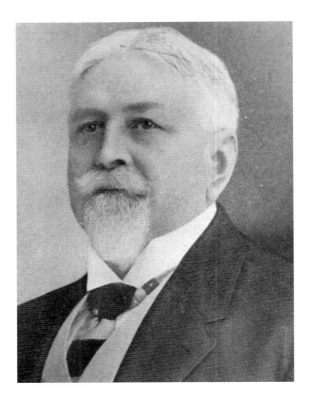

Peter Youree

Born in Lafayette County, Missouri, Peter Youree served in Slayback's Regiment of Confederate troops during the Civil War, rising to the rank of captain. The regiment was posted to the Trans-Mississippi Department, based in Shreveport. Their final duty was to surrender there in June 1865. Youree (1843–1914) decided to settle in Shreveport and was hired as a clerk in a mercantile store. He opened his own store and quickly became successful. He married Mary Elizabeth Scott in 1870. The Scotts were wealthy planters in East Texas and in Northwest Louisiana. Youree was a hard worker, and with his newfound social connections, was in a position to succeed. He became a true Renaissance man: an industrialist, capitalist, and futurist. Peter Youree owned and built Shreveport's first public transit system, a mule-powered trolley, and cofounded and operated Shreveport Waterworks Company, one of the nation's first public water systems to treat water with chlorine. Youree was elected president of Merchant & Farmers Bank in 1888, and three years later, became president of Commercial National Bank, a position he held until his death. He built Shreveport's first skyscraper, the Commercial National Bank Building, which, at 10 stories, towered above all other structures in the region. He financed the construction and operation of the massive Youree Hotel.

The Yourees built a large mansion on Fairfield Avenue at the site of the present-day Louisiana State Office Building. He named the home Youreeka. He became very involved in veterans' affairs and was a member of the General Leroy Stafford Camp No. 3 of the United Confederate Veterans in Shreveport. He also commissioned the sculpture that became the Confederate monument at the Caddo Parish Courthouse. The Yourees' son, William Scott Youree, died in Monterey, Mexico. His parents commissioned a copy of the *Angel of Grief* statue as his memorial. The Scott family cemetery is located in Scottsville, Texas, 30 miles west of Shreveport. They also built an English-style chapel in his honor. Peter Youree and his wife are buried in the Scottsville Cemetery under ornate monuments. When Peter Youree died in 1914, his wealth was estimated to be in excess of $2 million. He is honored with Youree Drive in Shreveport and Youree Middle School. His good works and sound business practices live on today. (Courtesy of Gary D. Joiner.)

CHAPTER THREE

Law and Politics

Shreveport began as a rough-and-tumble frontier town where gunfights occurred on the streets almost from the beginning. The first church service in Shreveport, conducted by Methodist bishop Leonidas Polk, almost did not occur, as an angry mob thought it would bring civilization to the all-but-lawless area. Since those dark days before the Civil War, Shreveport has seen a slow but steady increase in civilized behavior. This was usually accompanied by spurts of violence and public outrage. Until the turn of the 20th century, Shreveport recorded the third-highest number of lynchings in Louisiana. This frontier-style rough justice was considered to be good government throughout the West. It was economical, costing the taxpayers much less money than jury trials. It took the courage of a few brave people to stop this slaughter and lead the way to modern jurisprudence.

Judge Thomas Fletcher Bell and Gov. Newton Crain Blanchard are the two most notable figures in this civilizing cause. Others come to mind. Judge Alexander Boarman was the youngest mayor of Shreveport, and later, the oldest seated federal judge. Both prosecutors and defense attorneys have assisted in the process. Mayors, particularly long-serving politicians like Samuel Caldwell, Jim Gardner, John Hussey, and Clyde Fant, have helped mold Shreveport into what it is today. Caddo Parish police jurors and commissioners have left their mark on the law as well. School board members like Willie Burton and many others helped guide Caddo Parish into the modern, post-segregation era. In the 19th century, the African American senator and lieutenant governor Caesar Carpentier Antoine not only sponsored the legislation to make Shreveport into a city, but left a lasting legacy of good government and robust business in a period in which the South as a whole saw very little of either. This chapter highlights some of these brave people.

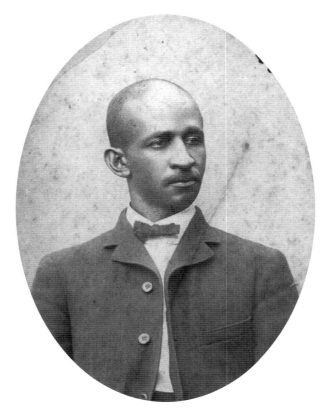

Caesar Carpentier Antoine

C.C. Antoine (1836–1921) was arguably the most successful African American politician in 19th-century Louisiana. A native of New Orleans, Antoine was a successful businessman. He was self-taught and became a barber. At the beginning of the Civil War, his family supported the Confederacy, and at least one brother joined the Confederate army. When Union forces took New Orleans in April 1862, Antoine helped organize the black militias into eight regiments, called the Louisiana Native Guards. He served in and was elected captain of Company I, 7th Louisiana Militia, which became the 7th Regiment, Louisiana Native Guards. The black units later evolved into the Corps d'Afrique, and still later in the war, became the US Colored Troops. He was one of the few black leaders to reach officer rank in the Union army. After the war, with Reconstruction becoming the law of the land, Antoine moved to Shreveport in 1866. He set up a grocery enterprise that was not simply a retail store; he wholesaled produce and goods to other stores across the state.

From 1868 to 1872, Antoine served in the Louisiana State Senate. He became lieutenant governor under Gov. Pinckney Benton Stewart Pinchback and also served in that capacity under William Pitt Kellogg. The state government was briefly deposed after the "Battle of Liberty Place" in New Orleans, but order was restored by the US Army. When Kellogg was impeached in 1876, Antoine served as governor for a matter of weeks. Shreveport became a city under legislation authored by Antoine in 1871. He also authored legislation creating the first organized police department in Shreveport and the construction of the first true city hall. He served as a commissioner for the New Orleans Exposition, or world's fair, in 1884. Antoine ran a black political group called the Comité, and financed and gave political backing to the *Plessy v. Ferguson* case in 1894. Antoine largely invented the wholesale grocery business in the South. He lived about half of each year in Shreveport, which was the northern anchor of his business interests. He lived his last 11 years there. He died on September 10, 1921, and is buried in New Bethlehem Baptist Church Cemetery. (Courtesy of LSUS.)

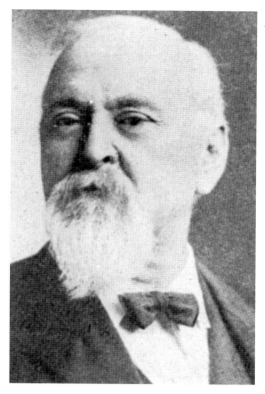

Thomas Fletcher Bell

Judge Bell played a pivotal role in "civilizing" Shreveport. He was a captain in the 8th and 11th Missouri Infantry regiments, Confederate States Army. Stationed in Shreveport at the end of the war, like his friend and compatriot Peter Youree, Bell remained in Shreveport. He was active in veterans' affairs and was an organizer and charter member of the General Leroy Stafford Camp No. 3 of the United Confederate Veterans. Bell was an attorney and served as adjutant general of the Louisiana State National Guard under both Gov. Francis T. Nicholls and Gov. Murphy J. Foster. He also served on the Caddo Parish School Board and as superintendent of Shreveport city schools. Bell was elected to a seat on the First Judicial District Court in Shreveport in 1903 and served until his death. The new Caddo Parish Courthouse was constructed in 1906, and Judge Bell planted the oak trees on the courthouse lawn from acorns he gathered at Audubon Park in New Orleans.

Bell's great legacy was to transform justice in Caddo Parish and Northwest Louisiana. As most western towns experienced rapid growth in the 19th century, Shreveport was no different. Swift judgment, often called rough justice, was the norm. Lynching was commonplace. Bell singlehandedly reversed this trend, forcing rigorous jurisprudence on Northwest Louisiana. In 1906, an African American man named Charles Coleman raped and murdered a white 13-year-old girl in Shreveport. A lynch mob of about 1,000 men tried to storm the Caddo Parish jail. Bell talked them out of lynching the man. Although the trial and its circumstances bear little resemblance to trials today, justice was served. Bell judicially forced Shreveport into the 20th century. Judge Bell also changed, at least for decades, racial opinions in the region. Booker T. Washington came to Shreveport in 1911, and Judge Bell served a guarantor of legitimacy. A surviving photograph shows him as the only white person on the dais, as 3,000 people came to hear Washington deliver an impromptu speech. Although the judge died the next year, in 1915, Washington returned and, this time, the audience was over 10,000 people, and the event had to be held at the state fairgrounds. Judge Bell died on November 14, 1912. He is buried in Forest Park East Cemetery in Shreveport. (Courtesy of Gary D. Joiner.)

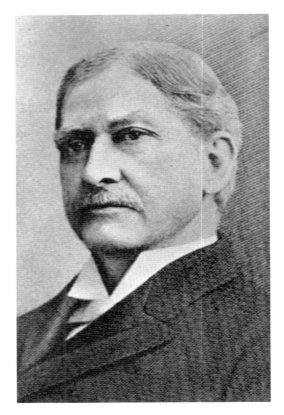

Newton Crain Blanchard

A native of Rapides Parish, Newton Blanchard (1849–1922) was schooled in Alexandria, Louisiana, and graduated from Tulane University (then the University of Louisiana) Law School in New Orleans. He moved to Shreveport and practiced law there beginning in 1871. In 1879, following the end of Reconstruction, the state needed a new constitution, and Blanchard served as a delegate. He was elected to Congress two years later and held that post for seven terms. Blanchard was the powerful chair of the Committee on Rivers and Harbors. He resigned from the House of Representatives to fill the vacant seat in the US Senate of Edward Douglass White, who was appointed to the US Supreme Court. Blanchard served three years (1894–1897) and did not seek reelection. That same year, he was elected to the Louisiana Supreme Court, serving until 1903. The next year, he was elected the 23rd governor of Louisiana. He served four years and then returned to practice in his adopted hometown of Shreveport.

Although Blanchard is considered a post-Reconstruction "Bourbon," or archconservative politician, he ushered in the beginning of progressive ideas in Louisiana. Along with his political allies, he began to tame wild frontier justice. During a large yellow fever outbreak in 1905, Blanchard almost caused a small civil war with Mississippi over the latter's quarantine of Louisiana. In 1906, while governor, Caddo district judge Thomas Fletcher Bell telegraphed Blanchard to request that he come to Shreveport immediately to preside as judge over the rape/murder case of Charles Coleman. With the streets congested with 1,000 members of an angry lynch mob, Blanchard boarded a special train and raced back to Caddo Parish. At each stop with a telegraph station, the governor told the Shreveport authorities where he was, how long it should take to get to Shreveport, and to ask the mob to be patient. It worked. The trial went on as scheduled, and Shreveport waited for the trial rather than lynching Coleman. Governor Blanchard was a member of the next state constitutional convention in 1913, serving as president. He died on June 22, 1922, and is buried in Greenwood Cemetery in Shreveport. (Courtesy of LSUS.)

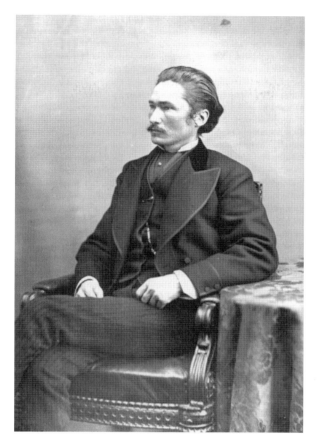

Alexander Boarman

Alexander "Aleck" Boarman (1839–1916) holds the distinction of being the youngest mayor of Shreveport, at age 26. When he died on vacation in 1916, he was the oldest seated federal judge in the United States. Born in Yazoo City, Mississippi, Boarman graduated from the University of Kentucky in 1860 and moved to Shreveport just prior to the Civil War. There, he read the law (at that time, the normal method of becoming an attorney) at the offices of Benjamin L. Hodge and F.D. Austin. When war broke out, Boarman served as a lieutenant in Company A of the Caddo Rifles, a company in the First Regiment of Louisiana Volunteers, Confederate States Army, raised in Shreveport. Boarman rose to the rank of captain. The unit served in the Army of Northern Virginia.

After the war, in 1866, Boarman returned to Shreveport, was admitted to the Louisiana Bar Association, and was elected major of the town. Forward thinking was one of Boarman's hallmarks. During Reconstruction, he began the first municipal fire department in Shreveport by purchasing a steam fire engine and locating it near the center of the urban buildings. He did not seek reelection, but was voted to the city council. After a single stint on the council, Boarman became the city attorney before he ran as a democrat in the newly created Louisiana Fourth Congressional District in 1872. This was highly unusual during the depths of radical Republican Reconstruction. He returned to his law practice in Shreveport in 1873 and switched parties to be a Republican. He was elected to a seat on the Louisiana 10th Judicial District in Caddo Parish until 1881. At that time, Boarman was chosen by Pres. James A. Garfield to hold a seat on the newly created Federal District Court for the Western District of Louisiana. He guided the construction of two federal courthouses in Shreveport. Upon his death in Loon Lake, New York, Boarman was buried in Oakland Cemetery in Shreveport. (Courtesy of the US First District Court for the Western District of Louisiana.)

Willie Burton

Burton is the most honored African American historian in Shreveport's history. He is an author, researcher, former president of the Caddo Parish School Board, a retired history professor at Southern University–Shreveport, and former chair of the social sciences department at SUSLA. The school is home to Burton's collection of research material and memorabilia. Burton was an active member in the civil rights movement, participating in marches for voter registration and working for school desegregation in the 1960s. Willie Burton has been a major influence on generations of young people in the Shreveport area for over 50 years. His published works include *On the Black Side of Shreveport: A History* (1994), *The Blacker the Berry: A Black History of Shreveport* (2002), and numerous articles. (Courtesy of the *Times*.)

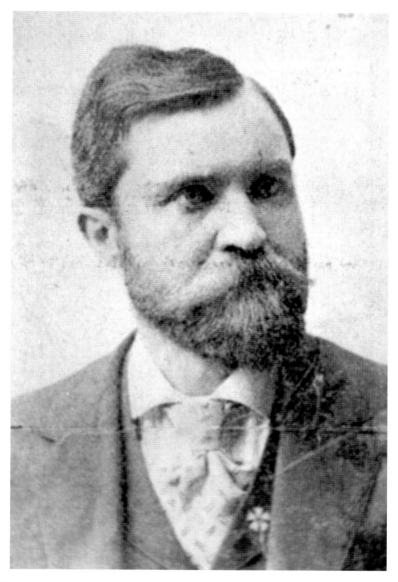

Clifton Ellis Byrd Sr.

A leading educator in Louisiana in the early part of the 20th century, Clifton Byrd was born in Bath County, Virginia, on the eve of the Civil War. He attended Augusta Military Academy in Stanton and the University of Virginia in Charlottesville. He was offered a principal's position in Monroe, Louisiana, in 1889 and then moved to the Pelican State. He left Monroe three years later to become the principal of the first public high school in Caddo Parish. Byrd (1859–1926) became the Caddo Parish school superintendent in 1899 and then, in 1905, became the fifth president of Louisiana Industrial Institute (today, Louisiana Tech University) in Ruston. After one year at that position, Byrd returned to Shreveport to resume leadership of Caddo Parish schools. Byrd held that position until his death in 1926. C.E. Byrd High School is named in his honor. He was a member of the Presbyterian church, the Masonic lodge, the Benevolent and Protective Order of Elks, Rotary International, and Sigma Nu fraternity. (Courtesy of LSUS.)

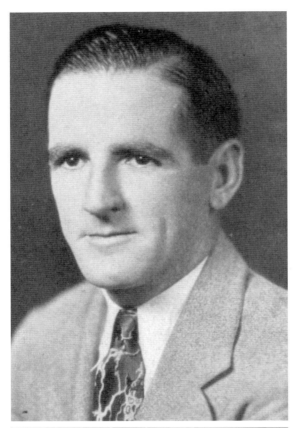

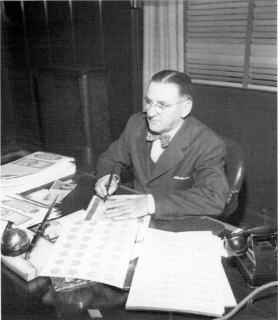

Samuel Shepherd Caldwell
Until the five terms of 1960s icon Clyde Fant, Samuel Caldwell (1892–1953) was Shreveport's most popular mayor, serving three successive terms (1934–1946) and guiding the city through the Great Depression and World War II. A native of Mooringsport, Caldwell unsuccessfully ran for governor in 1944 against another former city official, Jimmie Davis, and for two years prior to his election as mayor, he served on the Caddo Parish Police Jury. Caldwell headed the Louisiana Municipal Association. Among his achievements were his efforts to set up a recreation system fitting a city the size of Shreveport and to help organize the city parks and recreation council. Through Caldwell, the city obtained the former USO center in Princess Park. Caldwell was responsible for setting an eight-hour workday for the city's fire and police personnel, and lobbied for frequent pay increases for these key workers. He also obtained $2 million in funding for the city's first low-income housing and, according to his obituary, "established maternity, prenatal and dental clinics in the city." He also was responsible for the city acquiring Querbes Park, establishing Ford Park, and combining the city and parish health units into one body. (Both, courtesy of LSUS.)

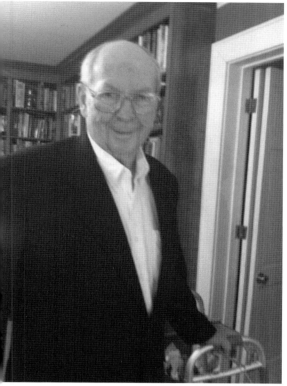

Art Carmody

Art Carmody (b. 1929) is arguably the dean of the Shreveport and Northwest Louisiana legal community, following the death in early 2015 of US district judge Tom Stagg. Carmody, a practicing attorney since the 1950s, has amassed a considerable library of military works and has established a reputation for historical analysis and military appraisal through a history column for the Shreveport Bar Association, as well as the Tarshar Society. A junior officer in the US Army prior to his legal work in Shreveport, Carmody is a member of the Louisiana State and Federal Fifth Circuit Bar Associations, a former president of the Shreveport Bar Association, a fellow of the American College of Trial Lawyers, and a member of the National Association of Railroad Trial Counsel, the Louisiana State Law Institute, and the Louisiana Association of Defense Counsel. He is a master in the Harry V. Booth and Judge Henry A. Politz American Inn of Court and has served on the board of trustees for the Louisiana State University Law Center. (Both, courtesy of the *Times*.)

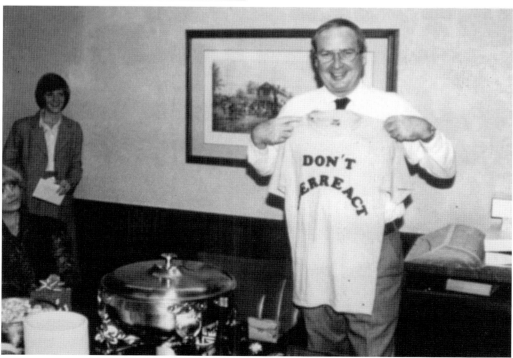

Johnnie Cochran

Johnnie L. Cochran Jr. was born in Shreveport in 1937. He received his bachelor's degree in business administration at the University of California–Los Angeles and his law degree from Loyola Law School. Cochran grew up in Shreveport, and the family moved to Los Angeles in 1955. He was intrigued by Thurgood Marshall and his victory in the *Brown v. Board of Education* case that destroyed the "separate but equal" doctrine dating to *Plessy v. Ferguson*. Cochran worked as a deputy city attorney for the City of Los Angeles and then as county assistant district attorney. He created a practice that catered to high-profile, wealthy clients, which gained him fame. His most famous work was in the acquittal of O.J. Simpson for the murder of his wife, Nicole Brown Simpson, and her friend Ronald Goldman. Cochran also defended Sean Combs, Michael Jackson, Tupac Shakur, Reginald Denny, and Marion Jones, among others. He died in Los Angeles on March 29, 2005. His body was taken back to Shreveport, where a memorial service was held at Little Union Baptist Church on April 8. Cochran was interred in Inglewood Park Cemetery in Inglewood, California. (Both, courtesy of the *Times*.)

Clyde E. Fant

Most Shreveporters under the age of 50 likely know of Clyde Fant only through the name of the modern parkway that links north and south Shreveport with a scenic drive along the Red River. But, to date, he remains the city's longest-serving mayor—20 years in five terms in two stretches, 1946–1954 and 1958–1970. Thanks to term limits, his record will stand. Originally from Linden in Cass County in East Texas, Clyde Edward Fant (1905–1973) was one of six children of John Preston Fant, a cotton processor and former Texas state legislator. A 1925 graduate of what is now East Texas Baptist University, Clyde worked briefly for a lumber company, then moved to Shreveport as an executive with an electric company in the late 1930s.

A Democrat who was able to make friends and cement deals on both sides of the political aisle, Fant was a remarkable public servant by almost any measure. He cleared the city's dismal riverfront area, which had become a shantytown, paving the way for the many public buildings erected there in the 1960s and 1970s, as well as the casinos and hotels that have sprung up in the decades following his death. Published histories say he was largely responsible for maintaining calm in the city during the tense 1960s, through public works and municipal programs that helped black citizens as well as white citizens in a time when the city and region were largely segregated. By one account, almost 7,500 substandard dwellings had been rehabilitated by the time Fant stepped down in 1970, and about 2,000 others were demolished. During the same period, the city saw the first public housing projects open. In 1948, Fant was one of four US mayors invited to The Hague, Netherlands, for the World Conference of Mayors. That brought him, and his city, national attention. He was named Louisiana's Mayor of the Year in 1953, a time when the National Municipal League and *Look* magazine selected Shreveport as one of the nation's top cities. (Courtesy of Centenary College of Louisiana.)

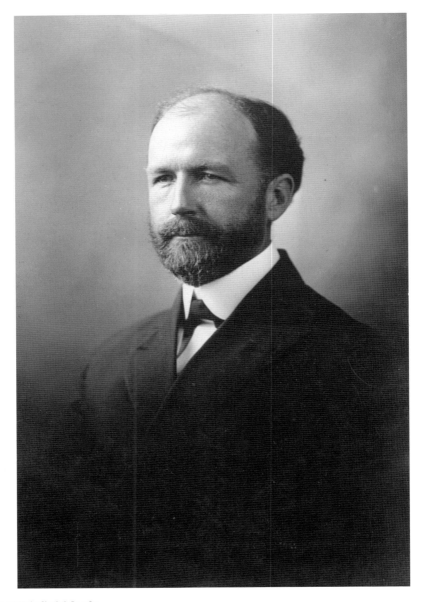

George Whitfield Jack

A US judge for the Western District of Louisiana, George Jack was nominated by Pres. Woodrow Wilson on March 6, 1917, to the seat vacated by Alexander Boarman. Confirmed by the Senate on March 16, he received his commission on March 16, 1917. Educated at Tulane University, Jack engaged in private practice in Shreveport from 1898 to 1910, as Shreveport city attorney from 1910 to 1913, and as US attorney for the Western District of Louisiana from 1913 to 1917. He was the father of Wellborn Jack Sr., an attorney and politician who served in a number of elected capacities in Shreveport and Caddo Parish, and of Maj. Gen. Whitfield Jack, who was on the staff of Gen. Matthew Ridgway at the close of World War II and delivered Ridgway's famous surrender request to German field marshal Walter Model. After exactly seven years on the bench, Jack died suddenly on March 15, 1924. (Courtesy of LSUS.)

Katherine Brash Jeter

Katherine "Kay" Jeter (1921–2011) was the grand dame of Shreveport history for four decades, shoulder-to-shoulder with her peer and occasional partner in research, Eric. J. Brock. Possessed of a steely legal mind and regal personality, she was an assiduous researcher, willing to spend hours in legal libraries and court nooks and crannies deciphering faded handwritten legal documents from ages past and discerning the treasures hidden within. Her research and scholarship revealed details of pioneer settlement in Caddo Parish and Shreveport, as well as long-lost nuggets of history, particularly regarding Confederate navy activity in Shreveport and the history of the ironclad warship CSS *Missouri*. She was a partner in the law firm of Tucker, Jeter, Jackson and Hickman, and its predecessor firms for 56 years until her retirement in 2003. She served as editor-in-chief of the *Tulane Law Review*. In 1982, she earned the distinction of being the first female judge to sit on the First Judicial District Court in Caddo Parish, Louisiana, serving as judge pro tempore from October of that year until March 1983. She also was honorary consul of France in Shreveport from 1982 to 1991. Her published works include *Historical Profile— Shreveport 1850*, coauthored with Fredricka Doll Gute, and *A Man and his Boat, the Civil War Career and Correspondence of Lieutenant Jonathan H. Carter, CSN*, published in 1996. (Courtesy of the *Times*.)

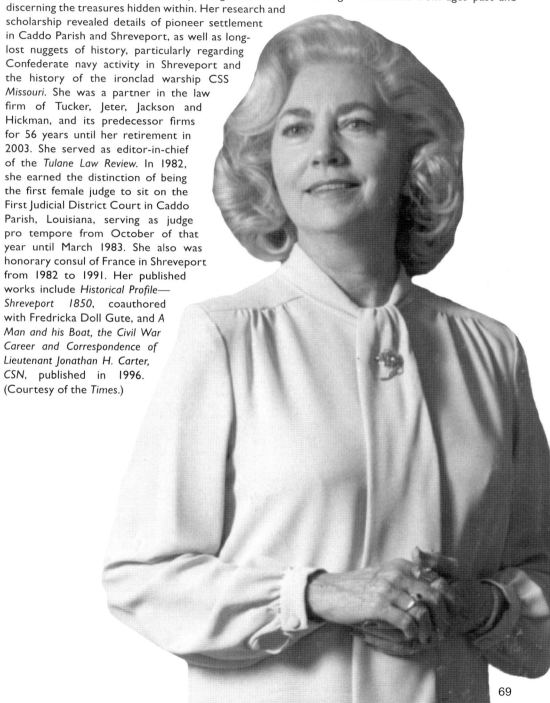

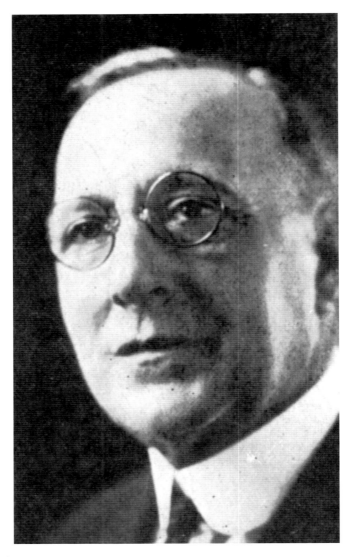

Andrew Querbes

New Orleans native Andrew Querbes (1864–1939) was a noted banker and businessman who moved to Shreveport by way of Mandeville in 1886. He immediately opened a retail grocery business, then moved into the wholesale arena, where he also proved a distinct success. In 1906, he was induced to leave the wholesale business and enter banking. Querbes was made the active vice president of the First National Bank, and in 1909, was made president of that bank, which position he held until his death. He also was an officer in the Shreveport Ice & Brewing Company, president of the Shreveport Ice Delivery Company, president of the Louisiana Cotton Growers' Co-operative Association, vice president and director of the Shreveport Mutual Building Association, and director of the First National Bank, the City Savings Bank & Trust Company, the International Banking Corporation, the Continental Flat Glass Company, and the Shreveport Chamber of Commerce. Querbes was a member of the police jury of Caddo Parish from 1896 to 1900. In 1904, he was elected mayor of Shreveport, serving two terms of two years each, declining a third term in the election of 1906. When the first good-roads committee was organized in 1900, he was chosen as its chairman, remaining until 1902. (Courtesy of the *Times*.)

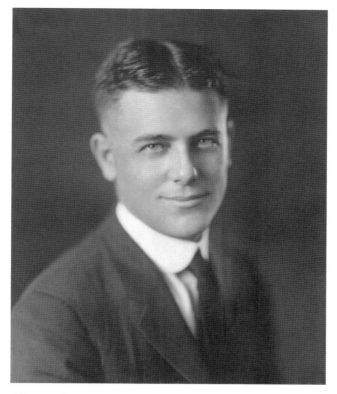

Charlton Havard Lyons Sr.

A very successful oilman, attorney, politician, and businessman, Charlton Lyons (1894–1973) was noted for being the first major politician in Louisiana to run, in 1964, as a Republican in the Democratic "Solid South" since Reconstruction. Lyons was born in Abbeville, Louisiana, and attended Louisiana State University and Tulane University, earning a bachelor's degree. He then attended Tulane University Law School and was admitted to the Louisiana Bar. While at Tulane, Lyons met Marjorie Gladys Hall, a student at Sophie Newcomb College and an aspiring actress. The couple married and moved to Rapides Parish, where he taught at Glenmora High School from 1916 to 1917. They then moved to Pollock in Grant Parish, where Charlton served as principal at Pollock High School. When the United States entered World War I, he served as a private, and Marjorie taught at Pollock High School. After the war, the couple moved to Winn Parish, where Lyons practiced law. In 1930 they moved to Shreveport, where he continued his practice and began another career in the oil and gas business. Within a few years, Lyons was named president of the Independent Petroleum Association of America. He served on the boards of both Tulane University and Centenary College. Although a Democrat since 1915, Lyons switched parties to become a Republican in 1960. He was a political rebel in doing so. He ran for governor in 1964, riding the popular sentiment for Arizona native Barry Goldwater. The state was 98 percent Democrat at the time. Lyons ran against John McKeithen from Columbia and lost. McKeithen, 45, played his youth against Lyons, 69. McKeithen also portrayed himself as a mainstream Democrat. Lyons was supported by Barry Goldwater, Ronald Reagan, and William F. Buckley Jr. Despite the overwhelming odds of running as a Republican in Louisiana, Lyons polled 37.5 percent of the votes. He became the chairman of the Republican Party in Louisiana. He relinquished the post several years later to David Treen. Charlton Lyons died in Shreveport. Among the lasting monuments to Charlton and Marjorie Lyons is the Marjorie Lyons Playhouse on the campus of Centenary College. The couple is still fondly remembered for their philanthropic and political activities. They are buried in Forest Park Cemetery in Shreveport. (Courtesy of the *Times*.)

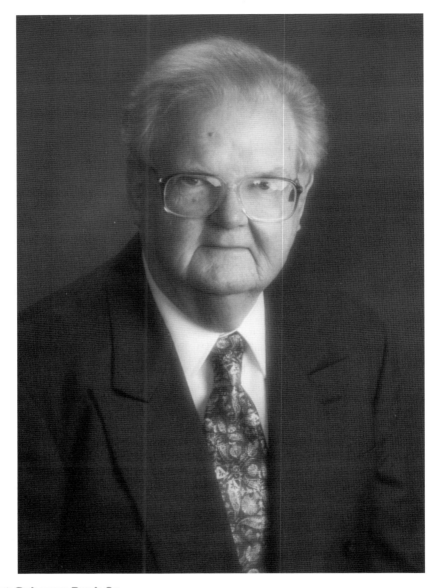

Robert Gahagan Pugh Sr.
A native of Shreveport, Robert Pugh attended school in Shreveport and Centenary College of Louisiana. He earned his law degree from Louisiana State University Law Center. Bob, as he was mostly widely known, was one of the most successful attorneys in the state of Louisiana. His legal interests ranged from constitutional law and sports law to oil and gas law. In each of these endeavors, Pugh made huge contributions. He was a close advisor to three governors: Edwin Edwards, David Treen, and Buddy Roemer. He represented well-known sports figures, particularly Terry Bradshaw, Joe Ferguson, Pat Tilley, and Joe Delaney. Pugh (1924–2007) was one of the principal authors of the current Louisiana State Constitution. He also crafted a law that imposed taxes on oil and gas passing through Louisiana. He updated the state's juvenile laws and chaired the Louisiana Supreme Court Historical Society. He and his son Bobby were the first father-and-son legal team to make oral arguments in a case before the US Supreme Court. (Courtesy of the *Times*.)

CHAPTER FOUR

Military

Caddo and Bossier Parishes were the home of military fortifications during the Civil War. The Confederate Army of the Trans-Mississippi was based in Shreveport. It was from this town that Confederate troops marched south to halt the Union invasion during the Red River Campaign of 1864. During the Spanish-American War and World War I, the region became important recruiting and training areas. Patriotism has always run deep here. The Great Depression and World War II saw huge increases in men needing jobs and joining the military services. During the Depression, Barksdale Field was acquired and built by the citizens of Shreveport cooperating with the War Department. World War II saw the airfield become a huge training base for the Army Air Corps. In 1947, Barksdale was transferred into the new US Air Force and soon became a major base for the Strategic Air Command. Today, it is home for the Air Force Global Strike Command, the Mighty Eighth Air Force, the Second Bomb Wing, and many auxiliary units. The commanders who have served at Barksdale are a who's who of the American military. As a major command center, now housing a four-star general for Global Strike Command, the base also has been home to lieutenant (three-star), major (two-star), and brigadier (one star) generals. The other services are well represented from this area. Gen. Charles C. "Hondo" Campbell hails from Shreveport. During the Indian Wars, Lt. Claiborne Lee Foster of the cavalry was born and raised in Shreveport. During the Civil War, commanders Lt. Gen. Edmund Kirby Smith and Maj. Gen. Richard Taylor both commanded armies from Shreveport. During Reconstruction, 1st Lt. Eugene Augustus Woodruff gave his life protecting the citizens of Shreveport from yellow fever. This chapter will highlight some of the best and brightest who commanded here or called Shreveport and Bossier City home.

Charles C. Campbell
The last continually serving officer of the US Army with Vietnam War combat experience, Charles "Hondo" Campbell (b. 1948) retired in 2010 after 40 years of service. His last post was as commander of US Army Forces Command, the Army's largest component. He entered the service in 1970, joining through Army ROTC at Louisiana State University. The Shreveport native, who returned to his hometown to live, comes from a family with long and established military roots. His father, Dr. James Campbell Jr., was an Army physician in World War II. His mother, Erena Witmer Campbell, was an Army nurse in the same conflict. A great-grandfather commanded a cavalry regiment in the czar's army prior to the Russian Revolution in 1917. A great-uncle was an admiral in the czarist navy. Campbell spent about half his Army career overseas, with multiple tours in Europe, Korea, and the Middle East. His last overseas assignment was as the commander of the Eighth Army in Korea, where he served more than three years. He also served as chief of staff for United Nations Command, Combined Forces Command, and US Forces in Korea. He also held lesser commands in Colorado, Texas, and Europe. (Courtesy of the *Times*.)

George Peyton Cole Jr.
Born in Florida but reared in Bossier City and Fort Worth, Texas, the child of a Strategic Air Command family, Brig. Gen. George Peyton Cole Jr. (b. 1944) made Air Force history with his August 1994 flight that recreated an around-the-world nonstop jet flight demonstrating the capabilities of the B-52 bomber. Cole's flight test-bombed a target in Kuwait before circling the globe to set records for the longest and second-longest jet sorties. Since retirement, Cole continues to serve the Shreveport–Bossier City communities through a number of civic and business activities. (Courtesy of the *Times*.)

Paul Thomas Cullen

Only a resident of the area for two years—from late 1949 to March 1951—quiet, lean Air Force Brig. Gen. Paul Thomas Cullen (1901–1951) remains one of the great enigmatic figures of the Cold War. Appointed the first commander of the 7th Air Division of Strategic Air Command and deputy commander and chief of staff of the Second Air Force, he was lost and presumed killed when his C-124A Globemaster II transport ditched and sank during a routine flight to the United Kingdom. Cullen and his command staff were picked up at Barksdale Air Force Base by the airplane that had left Walker Air Force Base at Roswell, New Mexico, with several dozen of the nation's top strategic bombing and nuclear-weapons personnel from the 509th Bomb Group, the nation's atomic bombing wing. On March 23, 1951, about 800 miles southwest of Ireland, the crew reported a fire in the cargo crates. The C-124 ditched, and all aboard reportedly exited safely. But, when the first rescue craft reached the scene 19 hours later, all that was found was a burned briefcase and a partially deflated life raft. Despite the largest air-and-sea search up to that time, not one body was found. Cullen and the 52 men with him had disappeared. Later, it was revealed that Soviet submarines and surface vessels were active in the area.

It has been speculated that Cullen and his companions were taken aboard Soviet submarines and brought to Russia for interrogation. Due to their expertise in nuclear and other defense matters, the men on the airplane would have been an intelligence windfall to the Soviets. Cullen had been the air service's leading expert on aerial reconnaissance and aerial photography, and had served as the head of photography at the Crossroads atom bomb tests in the Pacific Ocean in the late 1940s. He also had served as commander of the 2nd Operations Group on two occasions during World War II and had spent time in the Soviet Union. The Brig. Gen. Paul T. Cullen Award, an Air Force trophy for excellence in aerial reconnaissance, was named in his honor. (Courtesy of US Air Force.)

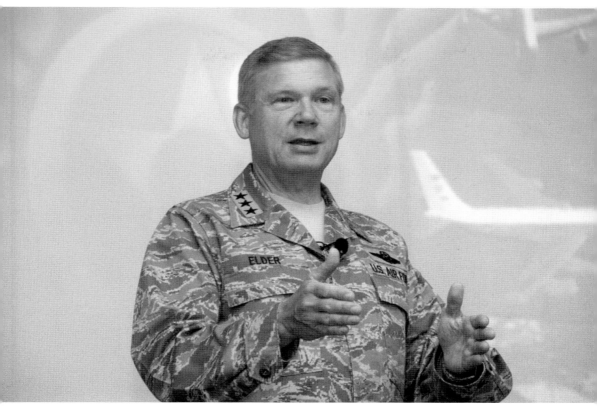

Robert J. Elder
Recently retired from the Air Force as a lieutenant general, Robert Elder (b. 1952) set in motion the creation of Air Force Cyber Command and increased service attention to war in the electronic realm long before "cyber" became a popular tagline. In addition to furthering research and study of cyber issues, Elder teaches at George Mason University in the Washington, DC, area, and leads a think tank at LSU-Shreveport. Elder is the latest, but not the last, in a series of military intellectuals and senior leaders blessed through the professional atmosphere offered by life in Shreveport–Bossier City and Barksdale Air Force Base. (Courtesy of US Air Force.)

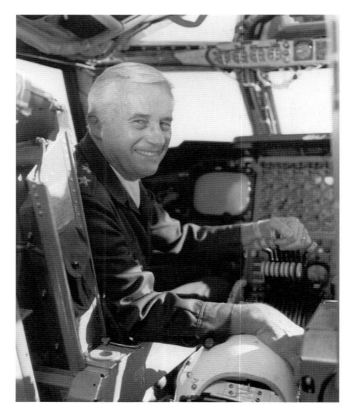

William Eubank

William Emanuel Eubank Jr. (1912–2010) was known as "Mr. B-52" for his pivotal role in introducing the venerable bomber into the Air Force inventory in 1955, flying the first example to Castle Air Force Base, California. As commander of the 93rd Bomb Wing at Castle, he also led its earlier acceptance of the B-47 medium bomber. Eubank had served as commander of the 2nd Bomb Group and on the senior staff of the new Strategic Air Command. His work on the B-47 transition made him a protégé of SAC commander Gen. Curtis LeMay. Eubank was a pilot and commander of the first around-the-world jet mission in 1957. This led to his wing receiving the coveted MacKay Trophy for the most meritorious flight of the year. In 1958, he commanded a 93rd Wing KC-135 flight that established a nonstop world speed record from Tokyo to Washington (13 hours, 47 minutes) and an unrefueled jet distance world record (10,288 miles, from Tokyo to the Azores). That demonstrated the ability of jet tankers to maintain pace with the new generations of jet bombers, allowing for the global control of the skies that later became key to SAC operations.

A native of West Virginia and originally a mine engineering graduate of Virginia Polytechnic Institute, Eubank instead joined the fledgling Army Air Corps as a flying cadet in early 1936. He first served with the 3rd Attack Group and 27th Bomb Group at Barksdale Field. He was commander of the 91st Bomb Squadron in the Philippines in 1941. After the Japanese attack destroyed the unit's bombers, Eubank took his fliers to the Bataan Peninsula, where they served as provisional infantry, then to Corregidor, where he was evacuated by a Navy submarine to Java. After Java fell to the Japanese, he flew to India to serve on the staff of Gen. Lewis Brereton in forming the Tenth Air Force. After the war, Eubank held the commands during which groundbreaking work was done with the B-47, B-52, and tankers, ending his career as deputy commander of the Second Air Force, at Barksdale Air Force Base, where he had begun his career. He retired in 1965 as a major general, with more than 4,500 hours, including 60 combat hours. (Courtesy of US Air Force.)

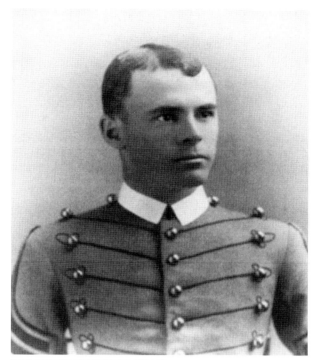

Claiborne Lee Foster

Foster (1865–1890) was one of three brothers who were sons of James Martin Foster, an extremely wealthy planter in Caddo and Bossier Parishes. Born and educated in Shreveport, Claiborne Foster graduated from the US Military Academy in West Point. Ranking near the top of his class, he chose the cavalry. His first assignment was as second lieutenant in Troop G of the 5th Cavalry Regiment, which took him to Fort Reno, Oklahoma, then called the Indian Territory. The Army was in the difficult position of keeping Indians from attacking settlers and, at the same time, prohibiting settlers from encroaching on Indian reservations. During a dispute with white settlers, Foster was recorded as stopping a riot without any violence and without any backup. Later, while at the fort, he contracted an uncontrollable fever and died. The witnesses to his death all reported that his final word was "happy." (Top, courtesy of LSUS; bottom, courtesy of Gary D. Joiner.)

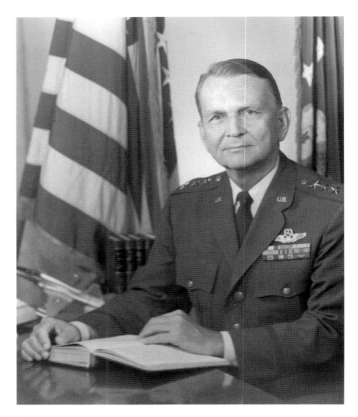

John Spencer Hardy
John Hardy (1913–2012) was born in Logansport in DeSoto Parish, south of Shreveport and just across the Sabine River from Joaquin, Texas. He attended Baylor University at Waco, Texas, and Louisiana Polytechnic Institute at Ruston. In 1938, he received a bachelor's degree from Centenary College in Shreveport. Getting his pilot wings at Kelly Field, Texas, in 1936, he was made a lieutenant in 1937 and remained on continuous active duty until he retired in August 1970. His first commissioned assignment was close to home, at Barksdale Field. In January 1942, as assistant chief of operations, he helped activate the Eighth Air Force headquarters, and that July, deployed to England with the unit to serve as its chief of operations in 1943. The following year, he was named chief of operations for the Army Air Forces in the Mediterranean, participating in planning for air offensives in southern Europe, the Balkans, and the Allied landings in southern France.

Hardy's postwar career also was illustrious. In 1949, he was a team chief in the War Plans Division and also on special duty with the Budget Advisory Committee of the Joint Chiefs of Staff at Air Force headquarters. He later commanded the 43rd Medium Bombardment Wing, 36th Air Division, Fifteenth Air Force at Davis-Monthan Air Force Base, Arizona, and in September 1952, was named commander of the 36th Air Division. In 1957, he joined the Pacific Air Forces headquarters at Hickam Air Force Base, Hawaii, serving as PACAF deputy chief of staff for plans and operations, then taking on similar duties with the unified command for the commander in chief, Pacific Command. In the 1960s, as a three-star general, his varied duties included stints as commander of Keesler Technical Training Center in Mississippi, commanding Third Air Force, and serving as chief of the Military Assistance Advisory Group for the United Kingdom. In late 1966, he became commander of Allied Air Forces, Southern Europe, and in 1968, took on his final post as commandant of the Industrial College of the Armed Forces at Fort McNair, Washington, DC. Hardy was a command pilot with 7,000 hours flying time in various military aircraft. (Courtesy of Beth Hardy Courtney.)

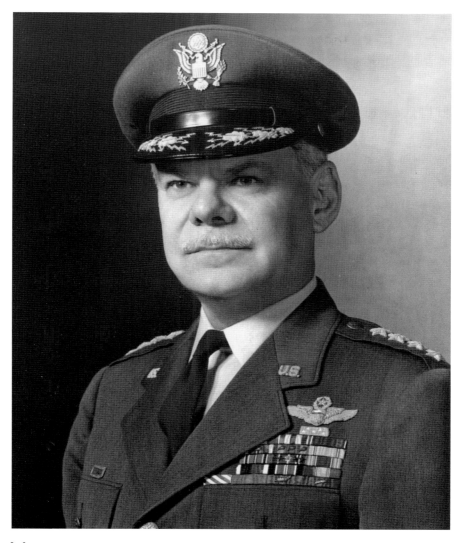

Leon Johnson

A full-rank general of the US Air Force and one of two living recipients of the Medal of Honor for the famous 1943 air attack on Nazi refineries at Ploesti, Romania, Leon William Johnson (1904–1997) served as meteorological officer at Barksdale Field prior to World War II and was stationed at the base briefly during and after the conflict. A 1926 West Point graduate, he was one of the first four flying officers of the Eighth Bomber Command (later part of the Eighth Air Force) that was activated in January 1942, and served as assistant chief of staff for operations. Johnson accompanied the Eighth Air Force to England in June 1942, and in January 1943, as a colonel, he assumed command of the 44th Bombardment Group. With Col. John Riley "Killer" Kane, Johnson was one of the five Medal of Honor recipients to emerge from the tragic Ploesti mission, code-named "Tidal Wave." Three of the five died during the mission. After a series of illustrious commands here and abroad after the war, Johnson retired in July 1961, but almost immediately was recalled to active duty to become the director of the Net Evaluation Subcommittee Staff for the National Security Council, serving until he retired again in 1965, with 39 years of active military service in the US Army, US Army Air Corps, and the US Air Force. After his military service, he was a consultant in the Washington, DC, area. (Courtesy of US Air Force.)

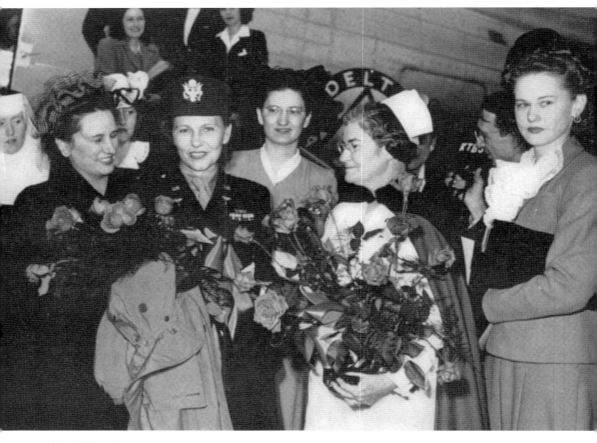

Edith Wimberly

A native of Campti in Natchitoches Parish, Edith Wimberly (1911–1964) was an Army nurse when she was sent with others in her field to serve in the garrison in the Philippines in the days just before the start of US involvement in World War II. Captured by the Japanese in early 1942 upon the surrender of Corregidor, she was evacuated to the prison camp at the University of Santo Tomas. There, Wimberly (second from left, in uniform) cared for fellow prisoners, including survivors of the Bataan Death March and Japanese abuses, from mid-1942 until early 1945, when she was liberated. She was a leading figure among the handful of nurses who have become known as the Angels of Bataan. Less political than some of her fellow nurses, Wimberly led a quiet and successful life as a military nurse until her early death, likely due to the indignities suffered as a captive. She was a recipient of the Legion of Merit and the Bronze Star. (Courtesy of the *Times*.)

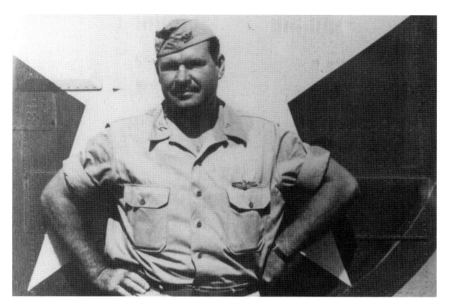

John Riley Kane

A native of MacGregor, Texas, John "Killer" Kane (1907–1996) was, with fellow Legendary Local Leon Johnson, one of two living recipients of the five Medals of Honor awarded for the August 1943 suicide bombing raid on Nazi refineries at Ploesti, Romania. Of the 177 B-24 bombers that took part in the low-level mission, more than 50 failed to return, and most of the airplanes that did survive were never fit to fly again. But the mission, with Kane in command of one of the bomb groups, broke ground for long-range assault and set a mold for innovation that the US Air Force pursues to this day. Kane and Johnson were true trendsetters. But Kane, son of the Rev. John Franklin Kane, one of Shreveport's more popular ministers, was known as a hard-nosed, boisterous, no-nonsense leader with a low tolerance for protocol and a propensity for telling incompetent people where to get off. So, while less capable peers advanced in rank, Kane stayed a colonel from the year he received the Medal of Honor (1943) until his retirement in 1956. He later retired to a farm in Arkansas, moving to Pennsylvania in 1987 after the death of his second wife. (Courtesy of the *Times*.)

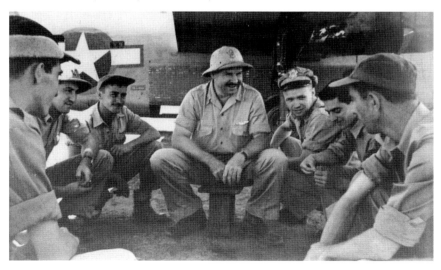

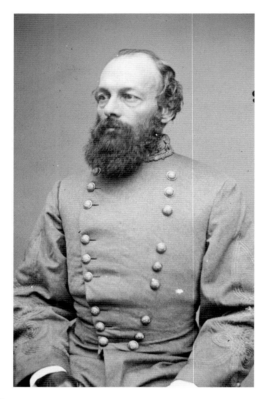

Edmund Kirby Smith

Smith (1824–1893), a native of St. Augustine, Florida, was educated at the US Military Academy at West Point, finishing 25th out of a class of 41. Upon graduation in 1845, Smith was assigned to the 5th US Infantry Regiment as a brevetted second lieutenant. Within a year, he was raised to the rank of second lieutenant and was transferred to the 7th US Infantry Regiment. He served in the Mexican-American War under both Gen. Zachary Taylor and Gen. Winfield Scott. After the war, Smith remained in the Army at the rank of captain, now serving with the 2nd US Infantry Regiment. He taught mathematics at West Point from 1849 to 1852 and then returned to the 2nd Infantry. He rose to the rank of major, then resigned his commission in 1861 to join the Confederate army. In February 1862, he commanded the Army of East Tennessee. He led one of two thrusts during the invasion of Kentucky and was appointed the rank of lieutenant general. Smith became the commanding general of the Confederate Department of the Trans-Mississippi in February 1863. This large department spanned the Confederate holdings on the Mississippi River west to the California border. Its headquarters was in Shreveport.

Smith ran his massive department with an autocratic air—the entire Trans-Mississippi Department was known as "Kirby Smithdom." He created the defenses at Shreveport and throughout the Red River Valley. In 1863 and 1864, Smith was in constant conflict with Richard Taylor, his commander in the District of Western Louisiana. Smith's philosophy was to build fortifications for defense and allow the enemy to be destroyed while attacking them. Taylor believed in mobility to defeat an enemy with superior numbers. Smith's bad decisions during the Red River Campaign of 1864 wasted the lives of thousands of his men. At the end of the war, Smith took his remaining forces to south Texas, where he intended to continue the war in Mexico. He was stopped before Confederate forces were able to cross the Rio Grande. Smith's forces were the last major Confederate units to surrender. After the war, he served as a professor at several colleges, finally becoming a professor of botany and mathematics at the University of the South at Sewanee, Tennessee. Smith died of pneumonia in 1893 and is buried in the University Cemetery at Sewanee. (Courtesy of the Library of Congress.)

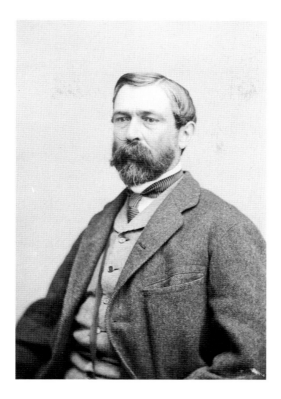

Richard Taylor

The son of Pres. Zachary Taylor and the brother-in-law of Confederate president Jefferson Davis, Richard Taylor (1826–1879) was born in Louisville, Kentucky. His sister, Sarah Knox Taylor, was Davis's first wife. He attended Harvard College before graduating from Yale University. Taylor was a member of the Skull and Bones Club at Yale. His principal interest was reading military and classical literature, and he was fluent in both Latin and classical Greek. Taylor suffered greatly from rheumatoid arthritis. While his father was president, Richard Taylor convinced him to buy Fashion Plantation in St. Charles Parish, Louisiana. He inherited the plantation upon his father's death. Taylor married Louise Marie Myrthe Bringier in 1851, and the couple had five children: two boys, Zachary and Richard Jr., and three daughters, Louise, Elizabeth, and Myrthe. The three daughters survived to adulthood, but the two sons died of scarlet fever in Shreveport in 1863 and are buried in Oakland Cemetery. Fashion Plantation was profitable, and the Taylors were among the wealthiest families in Louisiana.

At the beginning of the Civil War, Richard Taylor financed the 9th Louisiana Infantry Regiment and became its colonel. They were among the first troops from the state to be sent to Virginia. In October 1861, Taylor was promoted to the rank of brigadier general and saw action under Stonewall Jackson in the Shenandoah Valley. He led the Louisiana Tigers before requesting to return to Louisiana to help defend the state. Taylor was promoted to major general and commanded the Western District of Louisiana. He led Confederate forces during the Bayou Teche and Texas Overland campaigns in 1863 and during the decisive Red River campaign in 1864. Although quarrelling constantly with his department commander, Lt. Gen. Edmund Kirby Smith, Taylor won the accolades of the Confederate Congress and was promoted to the rank of lieutenant general. At the same time, he was given command of the Department of Mississippi, Alabama, and Eastern Louisiana. He surrendered that department in 1865. After the Civil War, Taylor became a fixture in elite social circles and moved to New York City. Taylor was a stalwart in Democratic Party politics. He authored *Destruction and Reconstruction*, considered one of the best autobiographies from any combatant in the Civil War. He died in New York within a week of the book's publication. (Courtesy of the Library of Congress.)

Courtney Stanley

Korean War veteran and Army corporal Courtney Louis Stanley (1933–1994) received the Distinguished Service Cross, the nation's second-highest award for bravery, for actions that saved the lives of soldiers trapped on Little Gibraltar Hill in Korea on March 17, 1953. Stanley, then only 19, was a courier for the 2nd Battalion of the 9th Infantry when he was trapped in an aid bunker with several wounded men, including Col. Harry Clark, commander of the brigade's 3rd Battalion. Armed with grenades and a Browning automatic rifle, for several hours, Stanley held off scores of bugle-blasting Chinese soldiers attacking the bunker in waves. Later, he was wounded and received a Purple Heart.

After recuperating from his wounds and being discharged from service, Stanley was honored—in the midst of Jim Crow times—with a mass celebration at Hirsch Coliseum on the Louisiana State Fair Grounds. The now-unemployed hero was greeted by mayors, generals, politicians, and more than 8,000 cheering supporters, as well as by Colonel Clark, who traveled from his own recuperation at Fort Benning, Georgia, to honor the man he credited as "the bravest man I ever saw"—and the man who saved his life. Clark recommended Stanley for the Medal of Honor, but it was denied for reasons that may have had to do with Stanley's race or his low rank, or both. It did not help that a front-page blurb on the *New York Times* had a well-meaning but naive sentiment from a civil rights leader, who said it would be a nice "gesture" to award Stanley the medal. Pres. Dwight Eisenhower, a former war leader and five-star general, bristled at awarding the Medal of Honor as a "gesture," even though, in Stanley's case, it was richly deserved. Courtney Stanley died on March 16, 1994, in Detroit, Michigan, of complications following surgery. (Courtesy of *The Times*.)

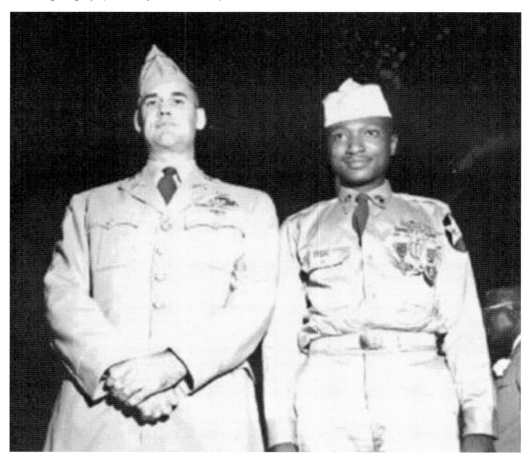

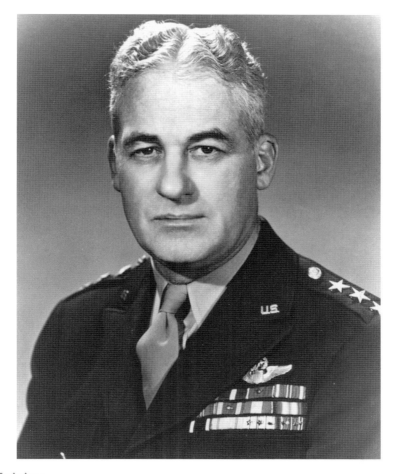

Nathan Twining

A full-rank four-star general at the close of his illustrious Air Force career, Nathan Farragut Twining (1897–1982) was stationed at Barksdale Field in the early 1930s. Originally from Wisconsin, he was the chairman of the Joint Chiefs of Staff from 1957 to 1960, the first from the Air Force. In 1917, he received an appointment to the US Military Academy at West Point, graduating in November 1918 under an accelerated wartime program, but too late for service in the war that had just ended. In 1919, he was sent to Europe and served in the infantry for three years, transferring to the Air Corps in 1926 and for the next 15 years. When World War II broke out, Twining was initially assigned to the US Army Air Staff in Washington, but in 1942, he was sent to the South Pacific, where he served as chief of staff of the Allied air forces. As a major general in 1943, Twining commanded the Thirteenth Air Force, surviving six days on a raft in the Pacific Ocean with 14 other people after their plane was forced to ditch. That November, he was transferred to Europe to take command of the Fifteenth Air Force from Gen. Jimmy Doolittle. In the final weeks of the war, Twining returned to the Pacific theater to command the Twentieth Air Force in the last air assault against Japan. In 1947, he took over Alaskan Air Command, but when Air Force vice chief of staff Gen. Muir Fairchild died in 1950, Twining was promoted to full-rank general to replace Fairchild. He became Air Force chief of staff in 1953, serving until 1957, when he was appointed chairman of the Joint Chiefs of Staff. He retired in 1960 and was inducted into the National Aviation Hall of Fame six years later. According to some UFO conspiracy theorists, Twining was a member of Pres. Harry Truman's secret Majestic 12, a committee of scientists, military leaders, and government officials formed in 1947 to facilitate recovery and investigation of alien spacecraft. (Courtesy of US Air Force.)

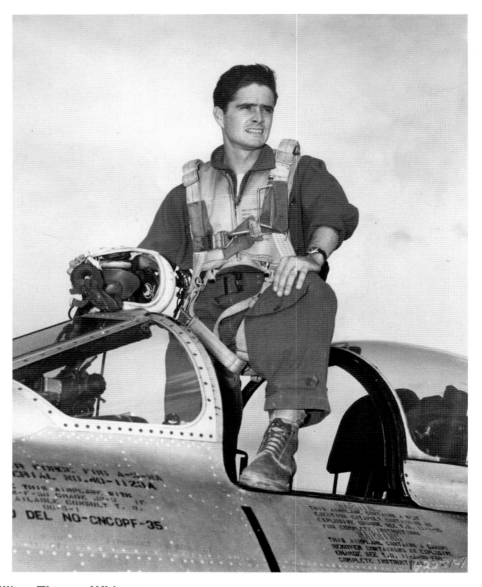

William Thomas Whisner

The only Air Force pilot to be an ace in both World War II and the Korean War and win the Distinguished Service Cross three times, Billy Whisner (1923–1989) downed 21 enemy airplanes. The Shreveport native won the Bendix Trophy Race in 1953, setting a then-record time of 3 hours, 5 minutes, 45 seconds, for an average speed of 603.5 miles per hour over 1,900 miles in a F-86F Sabre jet. His ace kill record consisted of 15.5 German planes in World War II, sharing a half credit with his commander, George Preddy. In the Korean War, Whisner downed 5.5 planes, becoming the 18th-leading ace among the nation's fighter pilots and flying as wingman to the legendary Gabby Gabreski. In World War II, four of his kills occurred in one fierce combat over the skies of Belgium, when he was one of 12 pilots who engaged 115 German airplanes on New Year's Day 1945. Ironically, he died from complications from the sting of a flying insect, a yellow jacket. Colonel Whisner was cremated, and his ashes were scattered in the Red River. (Courtesy of US Air Force.)

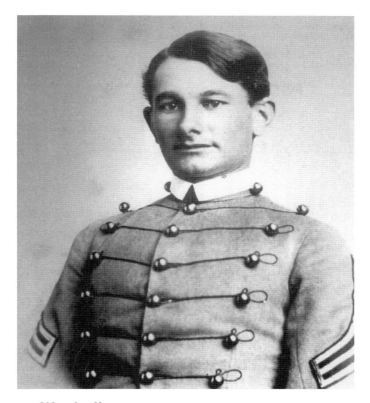

Eugene Augustus Woodruff

US Army first lieutenant Eugene Woodruff (1841–1873) was born in Avon, Connecticut, and died in Shreveport, Louisiana. His father died when Woodruff was young, and his mother moved the family to Independence, Iowa, in 1857. When the Civil War broke out, Woodruff volunteered for the 5th Iowa Infantry Regiment and was appointed second corporal in Company F. William Vandever, an Iowa congressman, secured an appointment for the young Woodruff at West Point in 1862. Woodruff graduated seventh in a class of forty-one in 1866. He served with the US Army Corps of Engineers, the most attractive unit in the Army. He was posted at St. Louis and New Orleans before being assigned the huge task of clearing the Red River of the logjam known as the Great Raft in 1872. Woodruff was the tactical commander at Shreveport, and his brother George was his second in command. Although the assignment was undertaken during Reconstruction, the unit was not part of the Army occupation force. At a time when the sight of a man in a blue uniform made Louisianans mad, the engineers were there to help. In August 1873, yellow fever broke out in Shreveport, killing one quarter of the population. Woodruff was ordered to evacuate his unit to Baton Rouge. He sent George out with the rest of the men, but remained to help the local populace. In doing this, the lieutenant was absent without leave.

Woodruff was a member of St. Mark's Episcopal Church, and the Reverend W.T.D. Dalzell was his priest. Together, the pair fought a heroic battle with the fever. Woodruff believed he would be okay, but he contracted the fever on September 23 and died at 9:00 p.m. on September 29. Shreveporters believed he was saint. They offered to send his body home to Iowa, but his mother said he should be buried in Shreveport, where he wanted to be. They offered to create a monument to him, but funds for the stone had already been donated. He was buried near the center of Oakland Cemetery in the Eltsner Lot. The Army denied his benefits to his mother, since he was AWOL. She fought the decision and was vindicated by an act of Congress. In 1933, his brother George returned to Shreveport. The monument was rededicated, and George was given the keys to the city of Shreveport. (Courtesy of Library of Congress.)

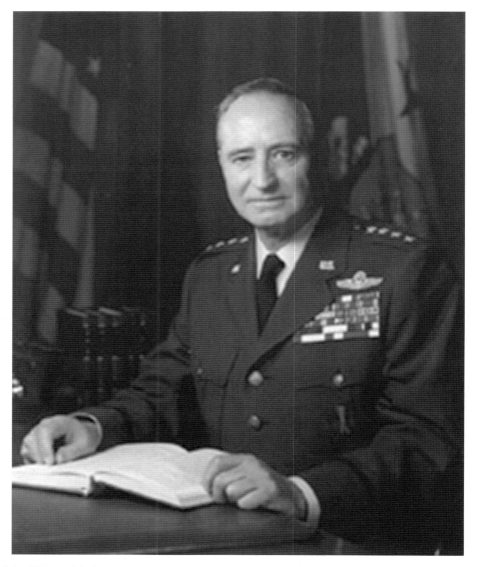

Archie Old and John P. McConnell
A pair of top Air Force generals in World War II and the Cold War briefly called the Shreveport area home in the mid-1930s, and each had a close brush with death, ironically on the same summer day in 1934. Archie Old (1906–1984) and John P. McConnell (1908–1986), both second lieutenants and budding pilots, crashed airplanes in separate accidents at Barksdale Field on August 7, 1934. Each walked away from their crumpled airplane. Had either man, or both, been seriously hurt or killed, Air Force history might easily have been changed. Old grew into a three-star general who led both the ill-fated but glorious air raid on Nazi ball-bearing plants at Schweinfurt, Germany, in October 1943 and the first shuttle-bomb mission from England to Russia in June 1944. He also piloted a B-52 in the January 1957 round-the-world mission in which William Eubank also flew. McConnell (pictured) served to pin four stars on his shoulders, held numerous senior staff and command positions in the China-Burma-India-Pacific theaters in World War II, returned to Barksdale to command the Second Air Force in the late 1950s, and finally served as Air Force chief of staff in the 1960s. (Courtesy of US Air Force.)

Numbered Air Force Commanders
At the end of the 1950s, the Strategic Air Command's global capability under Gen. Thomas E. Power posed a credible deterrent to Soviet aggression. Seen here conferring at SAC headquarters at Offutt Air Force Base, Nebraska, in 1958 are, from left to right, Lt. Gen. Archie J. Old, commander of the Fifteenth Air Force; Lt. Gen. John P. McConnell, commander of the Second Air Force and later Air Force chief of staff; Gen. Thomas Power; and Lt. Gen. Walter C. Sweeney Jr., commander of the Eighth Air Force. (Courtesy of US Air Force.)

Gabriel Disosway
Another promising pilot and second lieutenant at Barksdale Field in the 1930s was Gabriel Poillon "Gabe" Disosway (1910–2001), who, unlike Archie Old and John McConnell, fell in love with a Shreveport beauty, Dorothy Ford (1914–2010), and married her. That tie drew him back to Shreveport after he retired as the four-star head of the Air Force's Tactical Air Command in 1968. Today, he and his widow rest together in Forest Park Cemetery in Shreveport. A 1933 West Point graduate, Poillon served in numerous combat and command capacities in the European theater and in China in World War II, returning briefly to Barksdale just after the war to serve as assistant commander before moving on to his illustrious Cold War career. (Courtesy of US Air Force.)

CHAPTER FIVE

Saints and Sinners

"Saints and sinners" is an all-encompassing term for Shreveporters who have a noble heart, who are altruistic, public-minded, and act out of courage to help their fellow citizens. It also includes some less-glorious souls, who can be viewed as wicked or at least greedy and contemptuous. An optimist would hope that the good would outweigh the bad, and this is the case here. Highlighted in this chapter are ministers, scientists, physicians, healthcare administrators, civil rights activists, holocaust survivors, and people whose lives were cut short before their full potential bloomed. On the darker side, Shreveport has been the home for at least three serial murderers: Daniel Bryan Napier, Danny Rolling, and Nathaniel Code. Their crimes were heinous, and their fame spread far beyond Caddo and Bossier Parishes. Also covered is George D'Artois, the infamous commissioner who ran Shreveport through fear and intimidation in the civil rights era. Nature abhors a vacuum, and for this city, those who fought for change outnumbered the bad. African American ministers and others who challenged the status quo are profiled in the following pages. Reverends Harry Blake and E. Edward Jones, dentist Dr. C.O. Simpkins, longtime coroner Dr. Willis Butler, and 19th-century minister Dr. William Tucker Dickinson Dalzell all fought against overwhelming odds to make Shreveport a better place. Dr. T.E. Schumpert, Dr. James Clinton Willis Jr., Dr. Joseph E. Knighton Sr., Dr. Sirporah Solinsky Turner, Dr. Joseph Dudley Talbot, and James K. Elrod fought to make healthcare in Shreveport a priority and to make the region a safer place to live. Perhaps the best among us were the Van Thyns, Rosette "Rose" and Louis. They were Dutch Jews who were caught up in the Holocaust, sent to Auschwitz, bore unimaginable hardships, and survived. They moved to Shreveport and became inspirations to tens of thousands of people. This chapter shines light on the best and worst of humanity.

John Norris Bahcall

John Bahcall (1934–2005) was born in Shreveport. His early aspiration was to be a reform rabbi. A state tennis champion, he attended Louisiana State University as a philosophy major on a tennis scholarship. He transferred to the University of California–Berkeley and took his first physics class. He eventually became the Richard Black Professor of Astrophysics in the School of Natural Sciences at the Institute for Advanced Study at Princeton University. His work in theoretical physics led him to establish the Standard Solar Model and set him on his life's work of pursuing the solar neutrino problem. He and chemist Raymond Davis created an underground detector for neutrinos in an old South Dakota gold mine. Their experiment worked, but it yielded low results. It took 30 years for science to catch up to Bahcall's theories. The 2002 Nobel Prize in physics was awarded to Masatoshi Koshiba and Raymond Davis for their observations of neutrinos predicted by Bahcall's efforts. Bahcall also worked with NASA on the Hubble Space Telescope. Among his awards are the Heineman Prize, the National Medal of Science, the Gold Medal of the Royal Astronomical Society, the Fermi Award, the Benjamin Franklin Medal, and the Comstock Prize in Physics. Bahcall died in New York City on August 17, 2005. (Courtesy of *The Times*.)

Rev. Harry Blake

Blake (b. 1935) serves as the senior pastor at Mount Canaan Baptist Church in Shreveport and has held that position since 1966. He is president emeritus of the Louisiana Baptist State Convention. Born on a plantation near the town of Dixie in northern Caddo Parish, he became a field representative for Dr. Martin Luther King's Southern Christian Leadership Conference. This job put Blake at risk several times. Perhaps the most dangerous episode during this turbulent period in Shreveport came on September 22, 1963. A week after the bombing of a church in Birmingham, Alabama, that killed four young girls, Blake and other organizers wanted to lead a nonviolent march from Booker T. Washington High School to Little Union Baptist Church. The marchers were denied a permit by the police commissioner, George D'Artois. The organizers then decided to hold a regular service at the church. Following the service, the police, wearing riot gear, attacked Blake, beating him severely about the head. The police then attacked and scattered the crowd. Blake became an icon of the civil rights era. (Both, courtesy of LSUS.)

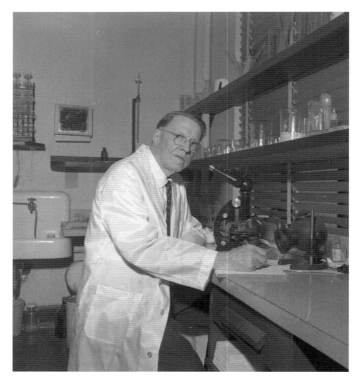

Willis Pollard Butler

Dr. Willis Butler was something of a local legend. Born in Gibsland, Louisiana, in 1888, he moved with his family to Shreveport in 1899 and graduated from Shreveport Central High School in 1907. From there, he went to study medicine at Vanderbilt University. Rapid advances in understanding diseases and their treatments completely transformed the role of the physician. Butler's natural and boundless curiosity drove him to investigate and question issues and to publish conclusions, even if they at times seemed controversial. His life path brought him back to Shreveport following his medical training. He served the community for decades, most notably as coroner of Caddo Parish (1916–1961 and 1973–1976). Butler married Annie Perry Dodd in 1913. Their alliance originated during Annie's frequent trips to Shreveport to visit her brother Monroe Dodd, the pastor of First Baptist Church. When Butler became coroner in 1916, he initiated a long term of service that witnessed important milestones in death investigations, including the use of photographs as evidence. Many years of public service made Dr. Butler prominent among the citizenry of Shreveport and cemented his ties to the community. He was so respected that city officials sided with him in one of the most controversial aspects of his tenure as Caddo Parish coroner, and the unwavering support of Shreveport officials probably saved him from federal indictment in 1923.

Perhaps Butler's most visionary service came from the establishment of a drug treatment clinic, which he operated from 1919 to 1923. It was first located at Shreveport's Charity Hospital, then the city jail, and finally at a house on McNeil Street in downtown Shreveport. The clinic's purpose was to treat those addicted to morphine by close supervision and decreasing dosages of the narcotic. The city's large number of morphine addicts alarmed Dr. Butler and moved him to address the problem in a meaningful and enlightened way. Dr. Butler believed that the city's morphine addiction rate was high because of two factors: incurable illnesses (such as cancer) and chronic pain brought on by years of manual labor. He wrote about his career as coroner of Caddo Parish in *Will Somebody Call the Coroner?* Dr. Butler died on June 1, 1991, and is buried in Hermitage, Tennessee. His record as the longest-serving public official in Caddo Parish is unlikely to be broken. (Courtesy of LSUS.)

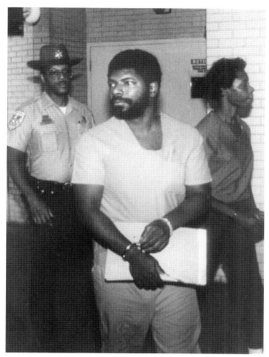

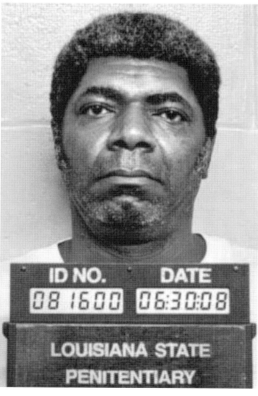

Nathaniel Code

Beginning in 1984 and continuing for the next three years, the Cedar Grove, Allendale, and Mooretown neighborhoods were gripped by fear from brutal murders. The Shreveport Police Department asked for help from the most famous FBI Behavioral Science Unit profiler, John E. Douglas. The cases that the police detectives took to Douglas included the death of Deborah Ann Ford, a 25-year-old black woman and a single mother of two. She was butchered in her home on August 30, 1984. More murders occurred in February 1986. Vivian Chaney and some of her family members were brutally murdered. August that year saw William T. Code and two of his grandsons killed in the same manner. Police patrols flooded the area, but the killer avoided them. A grandson of William Code, Nathaniel Code, was a suspect, but he was not pursued. The FBI's Behavioral Analysis Unit's profile matched Code almost identically. The evidence against him was overwhelming. Code was convicted and sentenced to death. He still awaits his fate, appealing his sentence today. (Both, courtesy of LSUS.)

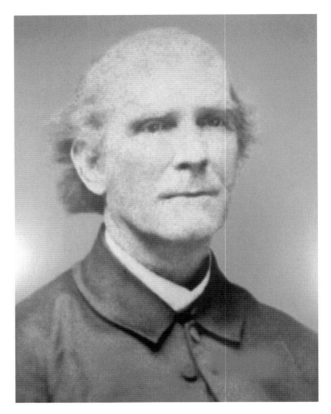

William Tucker Dickinson Dalzell

Born on the island of St. Vincent in the West Indies, William Dalzell studied medicine at both London and Oxford, and after receiving his license to practice medicine, he trained to be an Anglican priest. Dr. Dalzell (1827–1899) served the church in the Caribbean and in South America. While in Jamaica, he contracted a serious case of yellow fever. His narrow escape with death redirected his life. The disease took the life of his wife while on a trip to Venezuela. Dr. Dalzell moved to the United States in 1854. Savannah, Georgia, was in the midst of major outbreak of yellow fever, and that drew the priest and physician to the East Coast. After the fever abated, he moved to Pennsylvania and married the daughter of the bishop of Philadelphia. They moved to Houston, Texas, but were forced to leave due to their opposition to slavery.

In 1861, Dalzell became a chaplain for a Texas cavalry regiment and was posted in San Antonio. Dr. Dalzell's wife died, and he was then posted to New Orleans in 1865. He soon fell in love with Estelle Logan in the Crescent City. Dr. Dalzell accepted a pastorate in Shreveport the following year, at St. Mark's Episcopal Church. He joined the Shreveport Medical Society. Shreveport gladly accepted Dr. Dalzell into the community. In August 1873, yellow fever broke out in the city. He urged people in his congregation to leave the city, but the medical community did not agree that it was yellow fever in the early days. He and his wife remained to fight the fever. Over the next six weeks, fully one quarter of the population died. It was the third greatest outbreak per capita in US history. When yellow fever broke out in Memphis, Tennessee, in 1878, Dr. Dalzell went there to help. He served at Grace Episcopal Church in Memphis before returning to Shreveport in 1880. He was offered the high post of bishop, but did not wish to leave Shreveport. Dalzell died in the city on February 4, 1899, and is buried in Greenwood Cemetery as a hero. A new St. Mark's Church was built (now the Holy Cross Episcopal Church) six years after his death. The church, in its cornerstone, was dedicated "to the glory of God and the memory of Rev. Dr. W.T.D. Dalzell." (Courtesy of LSUS.)

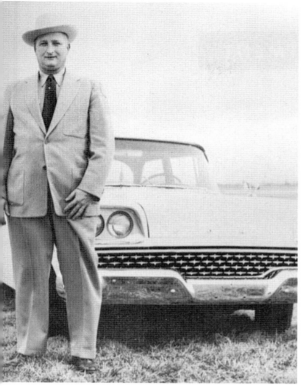

George Wendell D'Artois Sr.

George D'Artois (1925–1977), a native of Shreveport, attended C.E. Byrd High School, LSU, and Centenary College. He served as a sergeant in the Marine Corps and as the public safety commissioner of Shreveport from 1962 to 1976. This elected post made him the most powerful politician in Caddo Parish, exceeding even mayors. D'Artois was the face and voice of city authority during the civil rights era. As such, he was charged with "keeping the lid on" protests. He led the police response to a planned march at Little Union Baptist Church in which protestors and members of the congregation were attacked and Harry Blake was seriously wounded. Allegations of corruption increased through the 1960s and 1970s, and D'Artois's overbearing style made him many enemies. Investigations of corruption led to charges of theft and malfeasance of office. D'Artois was linked to the assassination of *Shreveport Times* journalist Jim Leslie in 1976. Charged with involvement in the murder, D'Artois was forced to resign. He died 10 months later during heart surgery in San Antonio, Texas. (Both, courtesy of LSUS.)

Monroe Elmon Dodd Sr.

Monroe Dodd (1878–1952) was born in Gibson County, Tennessee, and died in Shreveport. He earned bachelor's and divinity degrees, as well as a doctorate in divinity and a doctorate in law from Union University in Jackson, Tennessee. He obtained a second doctor of divinity degree from Baylor University in Waco, Texas. Dodd served as president of the Louisiana Baptist Convention and the Southern Baptist Convention. His ministerial career saw pastorates in Kentucky and in Los Angeles before he became the senior pastor at First Baptist Church in Shreveport. Dodd was a pioneer in using technology to preach the gospel. He saw the power of radio to spread his message. His sermons were broadcast nationally on KWKH in Shreveport, at that time one of the most powerful radio signals in the country. This allowed him to have great influence on the Southern Baptist Convention. Under his leadership, First Baptist Church became the first church in the nation to have its own radio station broadcasting on site. That church, built in 1907 at 515 Travis Street, is now the site of the Shreveport Municipal complex. Dodd moved the church to its present site on Ockley Street at the southern end of Highland Avenue to move away from the congestion of urban life in downtown Shreveport. In doing this, he practically forced the city to grow to the south. Dodd created a junior college for girls in 1925 at the site of the present-day church. He served as pastor at First Baptist Church from 1912 to 1950 and then as pastor emeritus until his death in 1952. He died in Los Angeles shortly after he retired from the pulpit, and his body was brought to Shreveport for interment in Forest Park Cemetery. (Courtesy of LSUS.)

James K. Elrod

A native of Courtland Community, Texas, James Elrod (b. 1937) attended Baylor University, graduating with a bachelor's degree in business administration. He then served in the Air Force as an officer. Elrod continued his education at Washington University School of Medicine, earning a master's degree in hospital administration. Following a residency at Baptist Medical Center in Jackson, Mississippi, he moved to Shreveport at age 27 to become the administrator of Willis-Knighton Memorial Hospital in 1965. Elrod has held that post for 50 years, and holds the record as the longest-tenured hospital administrator in the United States. At the time of his employment, Willis-Knighton had 80 beds and was a struggling entity on the far west periphery of Shreveport. Today, the Willis-Knighton Health System operates four hospitals, a number of outreach clinics, a regional physician network, and The Oaks of Louisiana, the largest retirement community in Louisiana. Willis-Knighton is the largest private employer in northern Louisiana. (Courtesy of the Willis-Knighton Health System.)

John Gray Foster

Foster (1878–1901) was one of three sons of James Martin Foster. His older brother, Claiborne Lee, died in 1890 while an officer in the cavalry in what is today Oklahoma. James Martin Foster Jr. ran the family holdings in Caddo and Bossier Parishes, and John Gray Foster, who graduated from the University of Virginia, returned home to help his brother in 1901. Their father had died unexpectedly in December 1900. John Gray was very popular at home, and, indeed, nationally. A handsome bachelor, he was well known in political circles. While at home, he reprimanded an employee who had brandished a gun to an overseer of one of the Foster properties. John Gray was attacked by the worker with a hoe. He went back to fire the man and received a shotgun blast to the chest. Foster died shortly after the attack. Within two hours of word of the attack being spread by telegraph, between 2,000 and 3,000 armed men on horseback came to avenge the killing. The suspect got away, but two associates were arrested in Bossier Parish and lynched. The story was covered coast to coast, and the general consensus was that the lynching was proper. (Right, courtesy of LSUS; below, courtesy of Gary D. Joiner.)

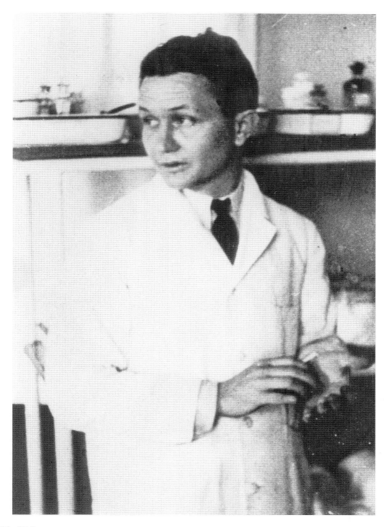

Dr. Edgar Hull Jr.
Edgar Hull (1904–1984), born and buried in Pascagoula, Mississippi, nonetheless factors greatly in the life and legend of Shreveport and Louisiana. He was a founding faculty member of the Louisiana State University Medical Center in New Orleans, and in 1966, became the first dean of the Louisiana State University School of Medicine at Shreveport (now the Louisiana Health Shreveport School of Medicine.) After retirement, he contradicted historian T. Harry Williams's account of the assassination and death of Huey Long, also a former Shreveporter. A pioneer in electrocardiography and a master of the American College of Physicians, Hull was a member of the American College of Gastroenterology, the American College of Cardiology, and the Catholic Physicians Guild. He worked to obtain national accreditation for what was then only the second public medical school in Louisiana. He was the dean of the Shreveport campus from 1966 to 1973, when he retired at the age of 69 to his native city. Hull was a practicing physician in Shreveport in the 1920s and early 1930s prior to moving to New Orleans. In Shreveport, he married Louise Parham, a daughter of O.J. Parham, creator of the famed OJ's Beauty Lotion. Hull later remarried. He had children from both marriages, and each became a physician. Hull is remembered through the Edgar Hull Society, founded in 1999 at the LSU School of Medicine to promote the study of internal medicine. (Courtesy of the *Times*.)

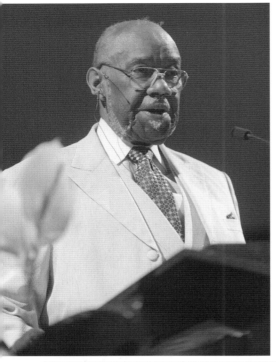

Rev. E. Edward Jones

Reverend Jones serves as senior pastor of historic Galilee Baptist Church in Shreveport. The Deridder, Louisiana, native is also president emeritus of the National Baptist Convention of America, having served as its president from 1986 to 2003. Jones (b. 1931) has served as pastor at Galilee Baptist Church since 1959. He has been a fervent civil rights activist. During the turbulent years of the 1960s, Reverend Jones organized many desegregation protests, and, perhaps most important, filed a civil lawsuit to desegregate the Caddo Parish schools. He was elected to the Caddo Parish Police Jury in 1970 and has served on the board of the *Shreveport Journal* and Grambling State University Foundation. Reverend Jones has remained an influential voice in both ecclesiastical and societal affairs. (Both, courtesy of the *Times*.)

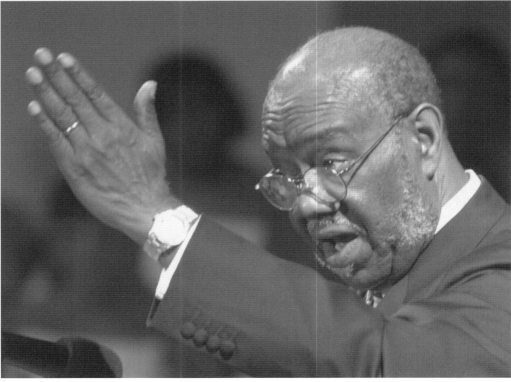

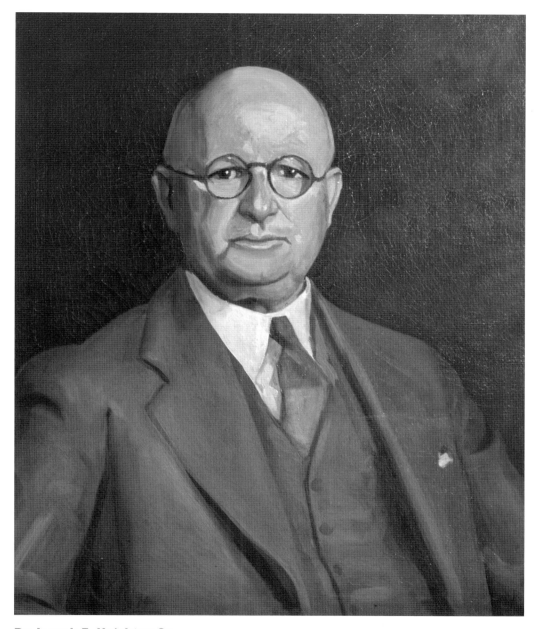

Dr. Joseph E. Knighton Sr.

Joseph Knighton attended schools in Claiborne Parish and Sunset, Texas. After graduating, he returned to Claiborne Parish and taught school for two years before attending medical school at Louisville Medical College and then the University of Nashville, graduating in 1899. Knighton (1870–1950) returned to Homer, the parish seat of Claiborne Parish, where he was born, to practice medicine. He moved to Shreveport in 1909 to begin medical practice, concentrating on digestive disorders. He joined Tri-State Hospital, which became Willis Knighton Hospital. Today, it is the Willis-Knighton Health System, the largest medical provider in northern Louisiana. (Courtesy of the Talbot Museum, Willis-Knighton Health System.)

Dr. Donald Mack
If Dr. Mack (b. 1931) is known for only one thing, it is his devotion to create the St. Jude Dream Home, first accomplished in Shreveport–Bossier City and, since 1990, used as a vehicle to raise millions of dollars nationwide for the famed Memphis, Tennessee, children's research hospital. Mack, a pediatrician, was born in Longview, Texas, the middle of five children, but grew up in Springhill, where his immigrant father, originally from Lebanon, opened the Willie Mack Department Store. (Both, courtesy of the *Times*.)

Dr. George McCormick II, MD, PhD
Dr. McCormick (1939–2005) served as the coroner for Bossier Parish from 1979 to 1982 and Caddo Parish from 1983 until his death. He received his bachelor's degree in biology from Southwestern at Memphis in 1961, followed by a PhD in physiology and biophysics from the University of Tennessee School of Basic Medical Sciences in 1965. McCormick completed his medical degree from the University of Tennessee College of Medicine in 1969. He performed his residency in pathology at the City of Memphis Hospitals and University of Tennessee School of Medicine in 1970. Dr. McCormick became an assistant professor of medicine at the Louisiana State University School of Medicine in Shreveport and served concurrently at the Overton Brooks VA Medical Center in Shreveport. He was nationally recognized in both the medical and legal fields for his work in forensic pathology. He published over 35 scholarly articles and made many presentations to academic and professional groups. Before his untimely death, McCormick was considered an extremely effective witness in courtroom trials and an absolute authority in the pathology arena. (Courtesy of the *Times*.)

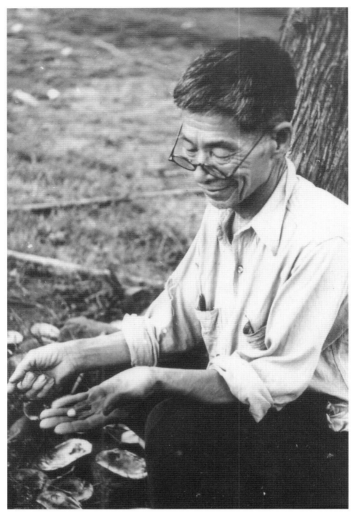

Sachihiko Ono Murata
Known as "George the Jap," Sachihiko Murata left his native Kagoshima, Japan, as a youth, stealing aboard a US Navy ship under the command of Adm. George Brown. He served as Brown's chef for several tours in the Pacific fleet, and when Brown retired, Murata settled first in New Orleans. Coming up the Mississippi and Red Rivers, he settled in Caddo Parish from about 1905 to 1910. Murata (1860–1946) finally settled on the north shore of Caddo Lake, just inside Texas, where his ability to cook and lead fishing expeditions made him a favorite of the authorities in both Caddo Parish, Louisiana, and Harrison/Marion Counties, Texas. He discovered pearl-bearing mussels in Caddo Lake sometime after 1900 and started a tiny industry of diving for them, until the creation of a dam in the early 20th century raised the water level of the lake, killing the mussels. When World War II came and Japanese were rounded up, the FBI went looking for Murata. Caddo Parish deputies and Texas law officers, reportedly under the direction of Texan "Cap" Taylor, Lady Bird Johnson's father, protected Murata from the agents, promising his good behavior. Murata was able to lead a peaceful and undisturbed life until his death just after World War II ended. According to stories in the *Shreveport Times* printed just before and at the start of the war, Murata was the son of a Japanese admiral, though this is unconfirmed. (Courtesy of the *Times*.)

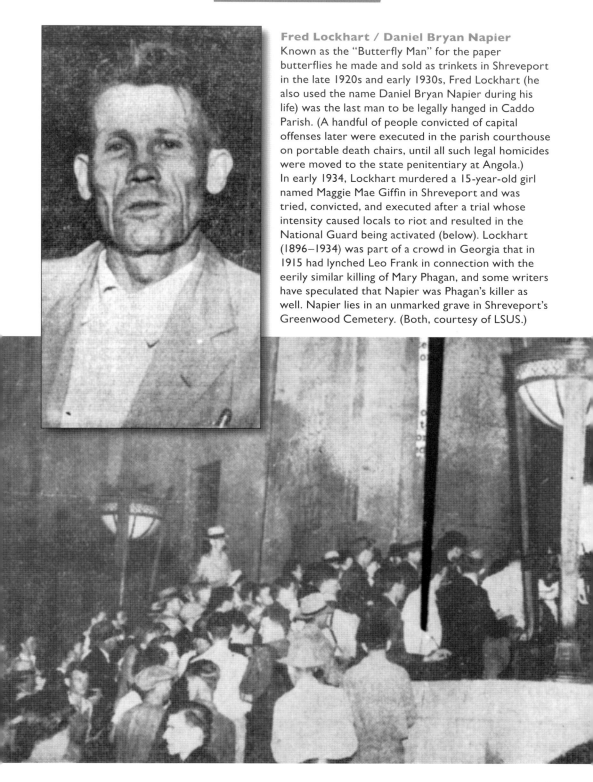

Fred Lockhart / Daniel Bryan Napier
Known as the "Butterfly Man" for the paper butterflies he made and sold as trinkets in Shreveport in the late 1920s and early 1930s, Fred Lockhart (he also used the name Daniel Bryan Napier during his life) was the last man to be legally hanged in Caddo Parish. (A handful of people convicted of capital offenses later were executed in the parish courthouse on portable death chairs, until all such legal homicides were moved to the state penitentiary at Angola.) In early 1934, Lockhart murdered a 15-year-old girl named Maggie Mae Giffin in Shreveport and was tried, convicted, and executed after a trial whose intensity caused locals to riot and resulted in the National Guard being activated (below). Lockhart (1896–1934) was part of a crowd in Georgia that in 1915 had lynched Leo Frank in connection with the eerily similar killing of Mary Phagan, and some writers have speculated that Napier was Phagan's killer as well. Napier lies in an unmarked grave in Shreveport's Greenwood Cemetery. (Both, courtesy of LSUS.)

Danny Harold Rolling

Rolling (1954–2006) was born and raised in Shreveport. The son of a police lieutenant who abused him, his mother, and his brother, Rolling committed three murders in Shreveport: William Grissom, 55; his daughter Julie Grissom, 24; and his grandson Sean, 8. Police suspected Rolling of the murders but did not arrest him. Rolling became nationally famous for another five murders in Gainesville, Florida, in 1990. The media tagged him the "Gainesville Ripper." It appears that robbery was his motive, but each of the murders exhibited unnecessary violence. Rolling was executed by lethal injection at the Florida State Prison on October 25, 2006. While awaiting execution, he wrote a diary about the Shreveport murders. He fancied himself another Ted Bundy and met a similar fate. (Courtesy of the *Times*.)

DR. T. E. SCHUMPERT.

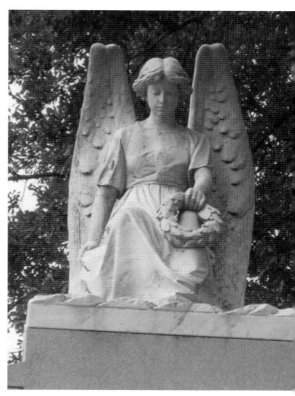

Dr. Thomas Edgar Schumpert

A well-known physician, surgeon, and administrator, T.E. Schumpert (1863–1908) left a lasting mark on the Shreveport medical community. He graduated from medical school at the University of Louisville in 1888, then returned to Shreveport and became a member of the board of health. Schumpert was elected president of the Louisiana State Medical Society in 1902. At the same time, he became the chief surgeon and administrator of the Shreveport Charity Hospital and the Shreveport Sanitarium, which he founded. He died of typhoid fever at the Shreveport Sanitarium on May 16, 1908. He donated his estate to the Sisters of Charity, which included the Shreveport Sanitarium. To honor his memory, the sisters renamed the facility the Schumpert Memorial Sanitarium, which became the Schumpert Memorial Hospital. (Left, courtesy of the *Times*; right, courtesy of Gary D. Joiner.)

John Thomas Scopes

John Scopes, born in Paducah, Kentucky, in 1900, attended the University of Kentucky, majoring in law with a minor in geology. Scopes rose to fame as the defendant in the famous "Scopes Monkey Trial" in Tennessee. This was a test case to throw out the State of Tennessee's Butler Act of 1925, which prohibited any schoolteacher from denying the biblical account of the origin of man. The courtroom in Dayton, Tennessee, became a stage for the greatest legal orators of the day. The prosecuting attorney was the fundamentalist religious leader and four-time presidential candidate William Jennings Bryan. The defense was led by Clarence Darrow, a renowned defense attorney and an agnostic. The jury found Scopes guilty, and the verdict was handed down on July 21, 1925. Scopes was fined $100. The Butler Act was upheld until 1967. The trial was made into a movie, *Inherit the Wind*. Scopes studied geology at the University of Chicago. He worked for the United Gas Company and was based in Houston and then Shreveport until his retirement in 1963. He died in Shreveport on October 21, 1970. (Both, courtesy of the *Times*.)

Cuthbert Ormand Simpkins

A native of Mansfield, Louisiana, Simpkins is a retired dentist and remains a cultural icon, having been at the forefront of the civil rights movement. His advocacy for racial equality, an end to segregation, and citizens' ability to obtain full voting rights cost him dearly. His home and lake house were firebombed, and his medical malpractice insurance was cancelled. Shreveport, at that time, was a tough place, living under the thumb of Commissioner George D'Artois. On August 14, 1958, Dr. Simpkins (b. 1925) was one of a group of activists who listened intently to Dr. Martin Luther King at Galilee Baptist Church in Shreveport. The speech was later honed and made famous by Dr. King as his "I Have a Dream" speech. To save his life and his family, Dr. Simpkins moved to New York City to practice dentistry. He became the vice chairman of the Southern Christian Leadership Conference, working with Dr. King and participating in the March on Washington in 1963. He eventually moved back to Shreveport, where he and his wife, Elaine, are active in medical advocacy for the poor. (Above, courtesy of LSUS; below, courtesy of the *Times*.)

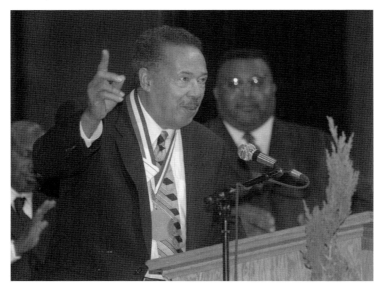

Rev. George Tucker

Born in Lebanon, Tennessee, on December 12, 1806, George Tucker was pastor of First Baptist Church of Shreveport from 1861 to 1865. In 1861, Reverend Tucker organized a company of soldiers, the Caddo Confederates, which became Company I of the 27th Louisiana Infantry Regiment. The regiment saw service during the Vicksburg campaign, playing a pivotal part in thwarting a major assault on the city's defenses on May 19, 1863. Tucker played a role in Shreveport's civilian life during the Civil War. The First Baptist Church, then located on Texas Street near the Caddo Courthouse, was one of the three largest churches in the Confederate capital of Louisiana. An ardent supporter of the Southern cause, Tucker also had a firm moral compass and did not waver from applying it.

Reverend Tucker was well known for an event that happened in his church on November 22, 1863. On that morning, he had delivered his sermon to the congregation and was preaching at another service for blacks. A Confederate unit of guerillas led by William Clarke Quantrill had to come to Shreveport to explain to the commander of the Trans-Mississippi Department, Lt. Gen. Edmund Kirby Smith, why they had burned down Lawrence, Kansas. The explanation seemed reasonable, and Quantrill assured Smith that the operation was a military necessity and that his men had behaved accordingly. One of Quantrill's captains rode his horse into the church and insulted Tucker's wife, Abigail. Reverend Tucker pulled out a pistol and killed the offending cavalryman, then continued the sermon. Quantrill and his band were ordered to leave Shreveport. Reverend Tucker died in Shreveport on December 31, 1882, and his wife, Abigail Hartsfield Tucker, died in June 1890 at age 75. They are buried in Oakland Cemetery in Shreveport. His modified obelisk faces true east rather than the cemetery's 41 degrees east of north, to coincide with the downtown streets. Instead of a cross, each of the four sides sports a large capital "T." (Courtesy of LSUS.)

Sirporah Solinsky Turner
A remarkable person with high aspirations for any era, but particularly in the early 20th century, Sirporah Turner was born in Galveston, Texas, in 1888. She moved to Shreveport when her mother took a job as a domestic servant for the Herold family in the city. Turner attended Bishop College in Marshall, Texas, followed by medical school at Meharry University in Nashville, Tennessee. Upon graduation with honors in 1907, she moved back to Shreveport. Turner established her practice at 1099 Texas Avenue, where she specialized in women's health and obstetrics. She is believed to be the first African American female physician in Shreveport. Turner was featured in an article in the *Indianapolis Recorder* in 1915 as a role model for young women in the United States. Turner practiced in Shreveport with her mother, Delilah Robinson, who assisted her daughter as a practical nurse. Dr. Turner moved to Los Angeles in 1920 to continue her practice. She always suffered from chronic medical issues, but practiced medicine until her early death from colon cancer in 1936. (Courtesy of the Talbot Museum, Willis-Knighton Health System.)

Rozette Lopes-Dias "Rose" Van Thyn and Louis Van Thyn
The diminutive Rose Van Thyn (1921–2010), a native of Amsterdam, Holland, lived through the perils of Auschwitz and became a symbol of survival and a quiet inspiration to succeeding generations. Rose and her family were arrested by the Nazis in Amsterdam in 1942 and moved by rail to Auschwitz as part of Adolph Hitler's "Final Solution" to destroy the Jews. She was the subject of medical experiments that should have left her barren or dead. She lost her parents, her sister, and her husband. Rose was moved to an equally infamous camp, Ravensbrueck, near the end of the war. She survived a death march and was liberated by Russian soldiers, then moved to an American Army camp. She returned to Amsterdam, where she met Louis Van Thyn, a Jewish Dutch soldier who had also been a prisoner in the Nazi camps. The couple married in Amsterdam in 1946. They and their two children immigrated to Shreveport nine years later, sponsored by the Shreveport Jewish Federation. They became US citizens in 1961. Rose and Louis were often called upon to share their stories, and they did so until their deaths in 2010 and 2008, respectively. (Courtesy of LSUS.)

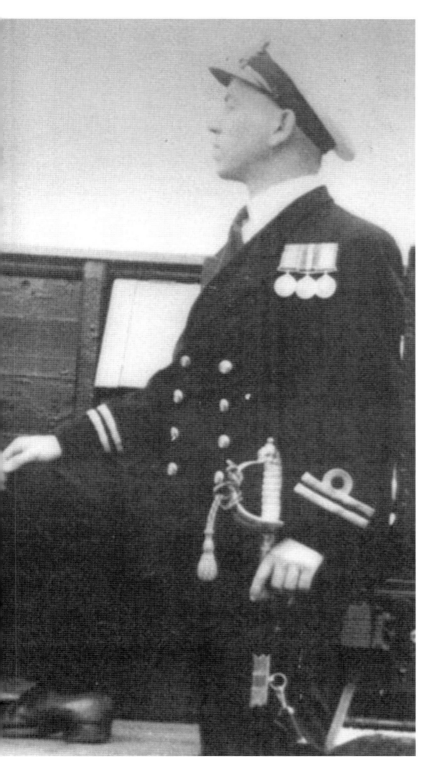

Dr. Donald Webb
Dr. Donald A. Webb (b. 1926) was born in Wales of English parents and lived his first nine years there, then moved with his family to England, where he remained until he immigrated to the United States in 1958. He served in the British Royal Navy from 1945 to 1953, rising to command the Isles-class trawler HMS *Switha*. Webb left the Royal Navy in 1953 to work five years in British Social Services, becoming ordained and building a reputation as a minister, educator, and scholar. In December 1977, he was installed as the president of Centenary College, an institution affiliated with the Methodist Church. Webb retired in 1991, but has continued to support the school and a variety of social, civic, and humanitarian causes in his adopted city as the school's president emeritus. (Courtesy of the *Times*.)

Dr. James Clinton Willis Jr.

A native of Claiborne Parish, James Willis was educated there and then attended Vanderbilt University in Nashville, Tennessee, where he received his medical degree. He returned to Claiborne Parish and practiced medicine for 14 years before moving to Shreveport. Willis (1865–1942) served in the Army as an officer in the medical corps before affiliating with the T.E. Schumpert Hospital in Shreveport. He became chief of staff after Dr. Schumpert's death. Willis took advanced training at both the Mayo Clinic and Johns Hopkins. He joined in a practice with Dr. Joseph E. Knighton. Together, they moved their practice to Tri-State Hospital. This organization grew to become the Willis-Knighton Hospital Health System. (Courtesy of the Talbot Museum, Willis-Knighton Health System.)

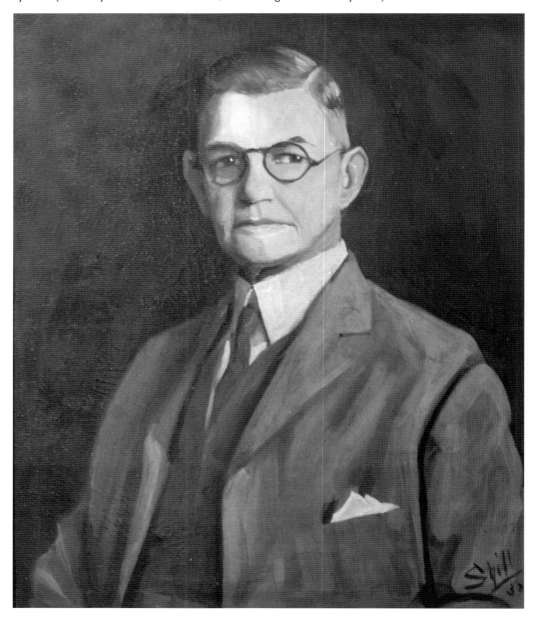

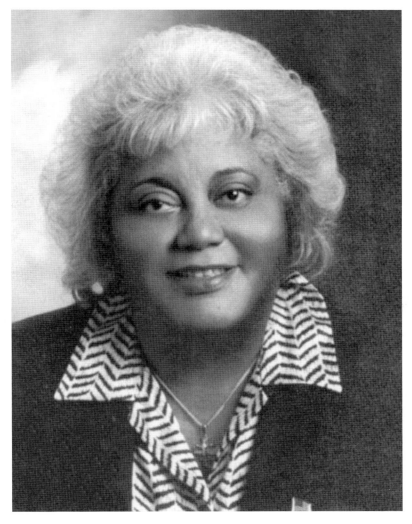

Maxine Sarpy
Maxine Sarpy (b. 1942) is a longtime political and community activist from Shreveport. She was the first woman to serve on the Shreveport City Council, filling the unexpired term of Greg Tarver when he was elected to his first term as Louisiana state senator. She is the widow of Dr. Joseph Sarpy, one of the leading African American physicians in Shreveport. Maxine Sarpy has been community minded and publicly active all of her adult life. She has served on several boards, including that of the Barnwell Art & Gardens, Mental Health Association of Northwest Louisiana, Caddo Council on Aging, Volunteers of America, and National Conference of Christians and Jews. She is also a former member of the board of American Electric Power–Southwestern Electric Power Company, Shreveport operation. She also served on the board of the Caddo-Bossier Port Commission from 1993 to 2007. She has been given the honor of having a street named for her in Shreveport. Sarpy is a registered nurse licensed to practice in Texas and Louisiana. In the past, she has been employed with Christus-Schumpert, where she was the head nurse in the psychiatric division; with the Community Action Agency as the director of health and education; and with Louisiana Family Planning Program as the area director of eight parishes. Maxine Sarpy has devoted her life to her community and has done much to bring all races together in Northwest Louisiana. (Courtesy of the *Times*.)

Dr. Joseph Dudley Talbot (OPPOSITE PAGE)

A prominent physician and businessman, Joseph Talbot (1914–2015) was born in Texarkana, Texas, and spent his childhood in Stamps, Arkansas. In 1932, he graduated from Stamps High School with honors as salutatorian. He received a full scholarship to the University of Arkansas, where he began his study in medicine. The scholarship available to him was in band, and he became the assistant drum major. He enjoyed telling this story throughout his life. In 1934, he continued his studies at Tulane Medical School, where his band reputation preceded him and he was asked to lead the school's band as drum major. He received his medical degree in 1938 and later interned and finished his residency at Charity Hospital and Tulane University in obstetrics and gynecology. He served as the doctor on a merchant ship, traveling to Cuba and Panama. In 1939, he received his orders as first lieutenant in the Army Reserves and served briefly at Fort Bragg, North Carolina, and Camp Shelby, Mississippi, before returning to New Orleans during World War II to treat patients.

After the war, Talbot moved to Shreveport, where he was a pioneer in ob-gyn at Tri-State Hospital, later Willis-Knighton Hospital. There, he organized the first obstetrics department with his partner, Dr. Thomas Glass. In his long career, Talbot proudly delivered over 6,000 babies before his retirement in 1998 after 60 years of service. Dr. Talbot served as both chief of staff and president of the Willis-Knighton Hospital and held memberships in the American Medical Association and the Shreveport Medical Association, where he served a term as vice president. He was a diplomat of the American Board of Obstetrics, a fellow of the American College of Surgeons and Gynecology, and held memberships in the Southern Medical Association, the Central Association of OB-GYN, the Southeastern Association of OB-GYN, Louisiana State Medical Society, and the Conrad Collins Association at Tulane University, as well as being a lifetime member of the Royal Society of Medicine in London, England. In 2006, because of Talbot's desire to preserve the history of Willis-Knighton Medical Center, which was founded in 1927, the Talbot Museum was established in celebration of the 80th anniversary of Willis-Knighton Hospital, with the support of Dr. and Mrs. Talbot. In May 2014, Dr. Talbot was honored at the opening of the new Willis-Knighton Innovation Center in Bossier, where the Talbot museum was relocated. (Courtesy of the *Times*.)

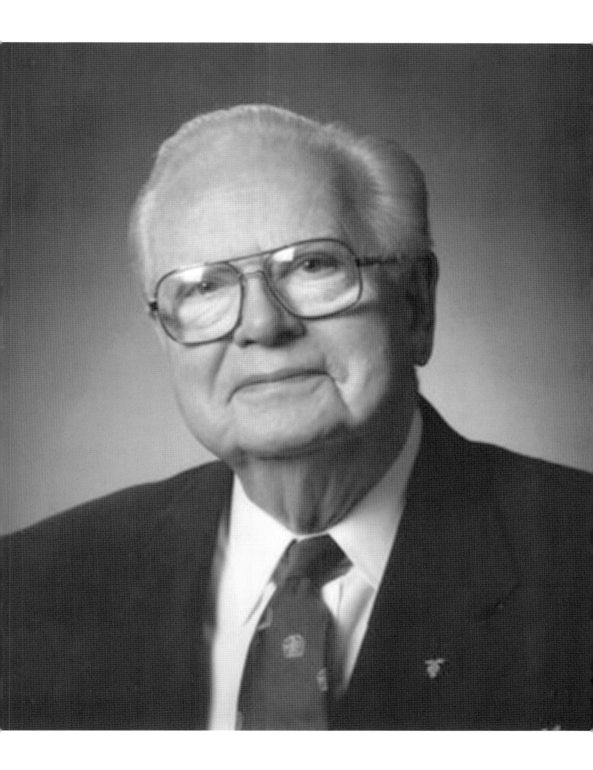

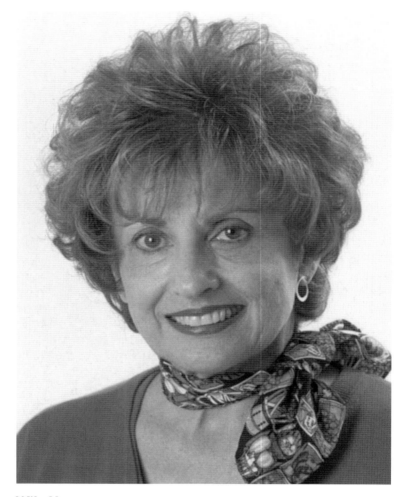

Emily Ann Wile Hussey

"Mimi" Wile Hussey (1937–2015) was a very popular former first lady of Shreveport, married to former mayor John Hussey. She was the daughter of Isidor Wile, a local businessman who founded the Big Chain grocery stores. Mimi, as all of her friends knew her, was a patron of the arts and a high-profile advocate for her city and her husband. From 1982 to 1990, she was the first lady of Shreveport. Always happy, always pleasant, always highly intelligent, Mimi Hussey epitomized what was good in her city. A graduate of C.E. Byrd High School and Pine Manor College in Massachusetts, she was the first female president of Holiday in Dixie and the Ark-La-Tex Ambassadors. She also served as president of Crime Stoppers in Shreveport, Mothers Against Drugs, the Shreveport Jewish Federation, the Toy Loan Board, the Council of Jewish Women, the Community Council, and Citizens for Sesame Street. She also served on the boards of the Shreveport Symphony Orchestra, One Great River, the Centenary Muses, Live Oak Retirement Center, the Junior League of Shreveport, the B'Nai Zion Sisterhood, the Northwest Louisiana Red Cross, the Literacy Council, the Louisiana State Exhibit Museum, Authors In April, the Red River Revel, and KDAQ Public Radio. Hussey also was an amateur actress and dancer, as well as a fierce advocate for literacy, understanding that if a child can read well, he or she will have an advantage over everyone else. She died after a long and courageous battle with lymphoma. She is considered to be one of those indispensable people, always there when a nonprofit group needed her or when something had to be done. (Courtesy of the *Times*.)

Leonard C. Barnes

Barnes (1922–2011), a native of Bogalusa, Louisiana, was the longest-serving chancellor of Southern University–Shreveport and, prior to that, served as a well-known and honored football coach at Booker T. Washington High School in Shreveport. Barnes, known as "Coach" by his students and others in the community, was truly a local legend. He graduated in 1940 from Central High School in Bogalusa. After service in the military, he graduated from Southern University in Baton Rouge in 1948, where he earned All-American status in three different years. After graduation, Coach Barnes and his wife, Doretha, moved to Shreveport, where Leonard was hired as the head coach at Central Colored High before it was moved and became Booker T. Washington High School. Barnes led the team to three state championships. He started at SUSLA, the Shreveport campus of Southern University, in 1967. He was named dean of the campus two years later, a position that eventually became chancellor. He held that position for 17 years, becoming the longest serving chancellor in the history of SUSLA (now Southern University–Shreveport). He retired from that position in 1987. While at Southern, Coach Barnes proved to be an excellent administrator and a superb mentor to his faculty and the student body. Although he was not the first chancellor on campus, he cemented the relationship between the campus, the Southern University system, and the community. He became the de facto ambassador for the school in northern Louisiana. His legacy survives not only in fond memories, but also at the institutions where he served. The football stadium at Booker T. Washington High School is named in his honor, and the Southern University–Shreveport administration building bears his name. (Courtesy of the *Times*.)

Aaron Rosenbaum Selber Jr.

A native of Baton Rouge, Louisiana, Aaron Selbert was the last president of the Selber Brothers department store chain. But, foremost, he was a philanthropist. Growing up during the Great Depression made a strong impression on him. His work ethic led him to take several jobs simultaneously, and he succeeded in each of them. He attended the private Southfield School in Shreveport and was later inducted into its hall of fame. Selber attended C.E. Byrd High School, then enrolled at Tulane University in New Orleans for his freshman year before joining the Air Force. He was trusted with a top-secret security clearance. Following his service, Selber attended Washington University in St. Louis and majored in retailing. He then returned to Tulane and completed his bachelor's degree in business administration. At Tulane, Aaron Selber met his future wife, Peggy Burkenroad. Peggy was a much-loved and noted philanthropist and artist in her own right. Aaron returned to Shreveport to run Selber Bros., turning it into a regional clothing business with stores in Louisiana and Texas. He was the third generation to run the business, doing so with his brothers. Selber Bros. sold its stores to Dillard's Department Stores in 1988.

Selber turned his considerable talents to investing and philanthropy and assisting nonprofits in both Shreveport and New Orleans. The couple established the Aaron and Peggy Selber Family Foundation in Shreveport and the Aaron and Peggy Selber Family Donor Advised Fund as part of the New Orleans Community Foundation. During his long career, Selber served as chairman of the board of the Blue Cross and Blue Shield Association of Louisiana and as director of Commercial National Bank in Shreveport, Goodwill Industries, Holiday in Dixie, the Louisiana Red Cross, and the Louisiana State University Health Sciences Center in Shreveport. The couple were members of B'Nai Zion Congregation in Shreveport. His motto was "Live your life in a wonderful way!" Aaron and Peggy did just that. (Courtesy of the *Times*.)

Carolyn Clay Flournoy
Carolyn Flournoy (1925–2003) was a native of Pine Bluff, Arkansas, but moved to Shreveport when she was nine years old. She was a graduate of Byrd High School in Shreveport, where she was a member of the National Honor Society. She earned a bachelor's degree in business administration from Centenary College and a master's degree in journalism from Northwestern University in Evanston, Illinois. Upon her return to Shreveport, Carolyn Flournoy (foreground) was a food columnist for the *Times* for 30 years. Her articles and recipes were eagerly anticipated, and her fame as a cook and socialite were widespread. She was active in the Republican Party and served as a delegate to the 1968 Republican National Convention. She was tireless in her efforts on behalf of Centenary College, acting as a member of the Centenary Muses and the Centenary College Book Bazaar and being selected to Centenary's hall of fame. Flournoy championed women's rights. A member of the Shreveport's Women's Commission and the Woman's Department Club, she headed Celebration of Women's Week. A member of the Junior League, she was named its Sustainer of the Year. Carolyn Flournoy was a life master in bridge. (Courtesy of the *Times*.)

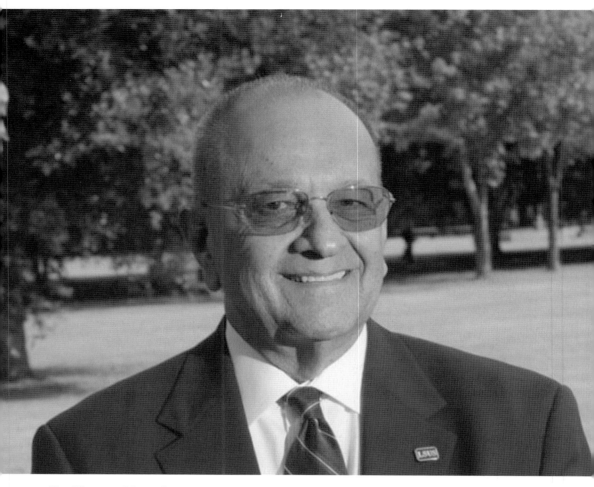

Dr. Vincent Marsala

Dr. Marsala (b. 1936) is a longtime public servant and educator. He received his bachelor's degree from Northeast Louisiana University and his master's degree in government and PhD in Latin American studies from LSU A&M. He joined Louisiana State University–Shreveport in 1967 when it first opened. Over the following 45 years, Dr. Marsala was a professor of history, department chair, dean of continuing education and public service, and, finally, chancellor, which he held for 17 years. To everyone in this region, the Monroe, Louisiana, native was "Mr. LSUS." His specializations include Louisiana history, Louisiana government, and Latin American history. Marsala succeeded John Darling as chancellor in 1995. At the same time, he was elected to the position of one of 12 Caddo Parish commissioners. Dr. Marsala's publications included an analysis of the political career of Louisiana US senator Joseph E. Ransdell of Lake Providence, who served in Congress at the turn of the 20th century and who sponsored the Ransdell Act, which created the National Institutes of Health. Marsala also edited, with Dr. Bill Pederson, *Abraham Lincoln: Sources and Style of Leadership*. He and his wife, Carol Ann, live in Shreveport. (Courtesy of LSUS.)

INDEX